LITTLE BOOK OF
TIFFANY
& CO.

Text © Tamara Sturtz-Filby 2025
Design and layout © Headline Publishing Group Limited 2025

Published in 2025 by Welbeck
An Imprint of HEADLINE PUBLISHING GROUP LIMITED

Tamara Sturtz-Filby has asserted her moral right to be identified as the author of this Work in accordance with the Copyright Designs and Patents Act 1988.

This book has not been authorized, licensed or endorsed by Tiffany & Co., nor by anyone involved in the creation, production or distribution of their products.

1

Apart from any use permitted under UK copyright law, this publication may only be reproduced, stored, or transmitted, in any form, or by any means, with prior permission in writing of the publishers or, in the case of reprographic production, in accordance with the terms of licences issued by the Copyright Licensing Agency.

Cataloguing in Publication Data is available from the British Library

ISBN 9781035420568

Printed in China

Headline's policy is to use papers that are natural, renewable and recyclable products and made from wood grown in well-managed forests and other controlled sources. The logging and manufacturing processes are expected to conform to the environmental regulations of the country of origin.

HEADLINE PUBLISHING GROUP LIMITED
An Hachette UK Company
Carmelite House
50 Victoria Embankment
London EC4Y 0DZ

The authorised representative in the EEA is Hachette Ireland,
8 Castlecourt Centre, Dublin 15, D15 XTP3, Ireland (email: info@hbgi.ie)

www.headline.co.uk
www.hachette.co.uk

LITTLE BOOK OF

TIFFANY
& CO.

The story of the iconic brand

TAMARA STURTZ-FILBY

CONTENTS

INTRODUCTION 6
THE EARLY YEARS 14
THE TIFFANY DIAMOND 34
BLOOMS AND BOTANICALS 42
FROM BROADWAY TO FIFTH AVENUE 58
TIFFANY BLUE 78
LOVE AND ENGAGEMENT 86
TIFFANY IN FASHION 96
JEAN SCHLUMBERGER 114
ELSA PERETTI 124
PALOMA PICASSO 136
A CULT ICON 144
INDEX 156
CREDITS 160

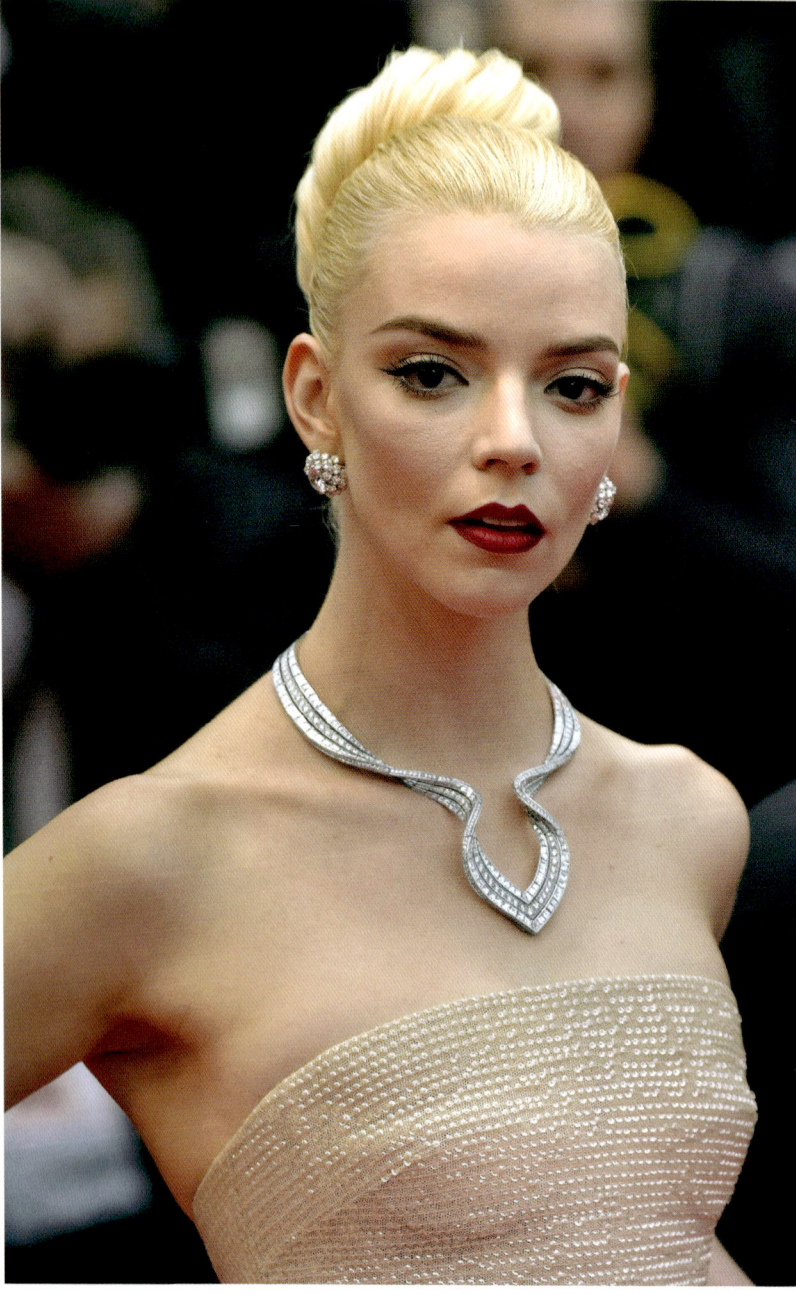

INTRODUCTION

"New York is a place where people come to have their dreams realized. So many people not only come to the city, but ultimately make their way to Tiffany."

Katie Couric, TV presenter, *Crazy About Tiffany's*

As a young career girl in London in the 1990s working at *Harper's & Queen*, I had a very specific goal, along with my peers: to purchase something from Tiffany & Co. My choice happened to be a sterling silver heart key ring – the cheapest item in the store at the time – but we could choose anything as long as we came out with the little blue box, such was the cachet and lure that Tiffany held. And still does.

My first piece of Tiffany jewellery was Elsa Peretti's famous sterling silver open heart necklace, and when my husband proposed, of course my engagement ring came from Tiffany & Co. The jeweller has a reputation that surpasses all others, and the opening scene of Audrey Hepburn's Holly Golightly staring longingly at Tiffany's window in *Breakfast at Tiffany's* is one of the most iconic images in cinematic history.

OPPOSITE Actress Anya Taylor-Joy at the 77th Annual Cannes Film Festival, wearing an exquisite Tiffany High Jewellery diamond necklace with over 68 carats.

Who has not longed to find a Tiffany blue box with its teasing white satin ribbon under the Christmas tree or not dreamed of those magical words that Trey said to Charlotte outside the Fifth Avenue store in *Sex and the City*: "Maybe we should go in there and find you the most beautiful ring that they have."?

The Tiffany & Co. of today is a far cry from the stationery and "fancy goods" store opened by two friends, Charles Lewis Tiffany and John Burnett Young, on Broadway in New York's Manhattan in 1837. Nearly 190 years later, it has more than 300 stores around the globe and employs 14,000 staff, including 3,000 skilled artisans, and has a brand value of approximately $7 billion. But there is still so much more to the famous name than meets the eye.

Steeped in a rich history of the Gilded Age, art nouveau, art deco and the changing face of American society which saw Tiffany rise to new heights, it also survived a civil war, two world wars and the Great Depression. American presidents came and went, although not without their fair share of Tiffany goods – Abraham Lincoln purchased a Tiffany seed pearl necklace and earrings for his wife to wear to the inaugural ball in 1861; a sterling silver hunting knife was made for Theodore Roosevelt in 1884; Dwight Eisenhower designed a Tiffany pendant for the First Lady; John F. Kennedy commissioned Jean Schlumberger, Tiffany's renowned designer, to create a berry brooch for Jackie Kennedy after the birth of their son; and when the Obamas attended the Diamond Jubilee of Elizabeth II in 2013, they presented her with a vintage 1950s Tiffany & Co. silver make-up compact.

OPPOSITE Possibly the most famous packaging in the world: nothing says Tiffany & Co. more than the robin egg-blue box with its white satin ribbon.

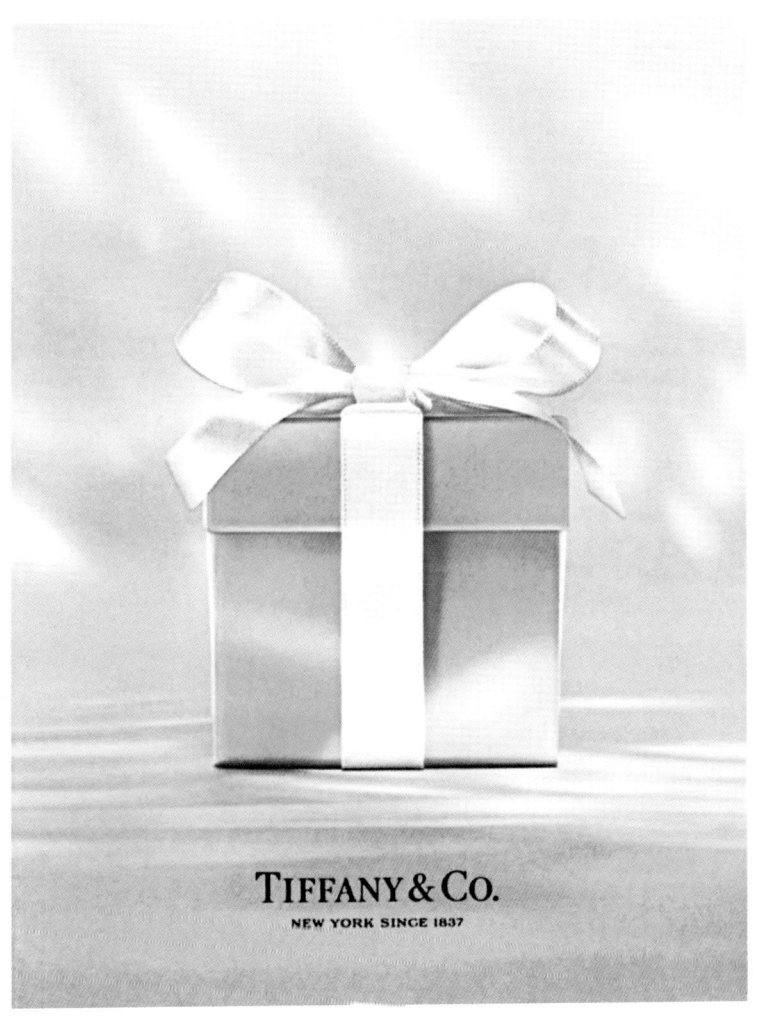

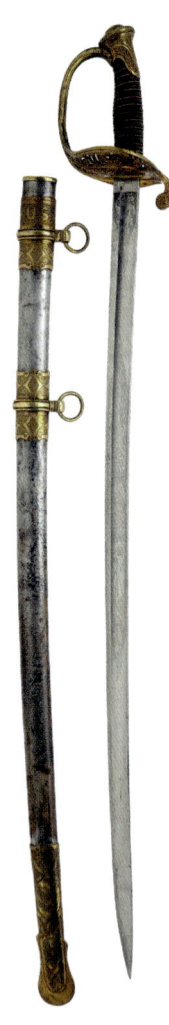
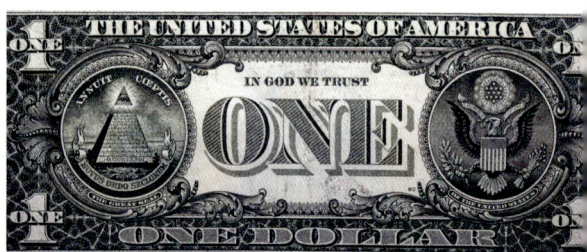

Many of us think of jewellery, especially diamonds, when we hear the name Tiffany, but it wasn't always that way. During the American Civil War between 1861 and 1865 it focused its efforts on making ammunition, including rifles, swords, cutlasses and bugles, even medals for both sides, and it would turn its attention once again to military needs during both world wars. In 1885, Tiffany redesigned the Great Seal of the United States, which still appears on the one-dollar bill today, and the following year, the company designed the invitations for the inauguration of the Statue of Liberty, featuring a gold embossed wreath with crossed flags, and an image of the statue on its pedestal, as well as the shields of both America and France.

LEFT Engraved by Tiffany & Co., this Staff and Field Officer's sword was presented to Colonel Peter Kinney, Commander of the 56th Ohio Volunteer Infantry, 1861–63.

ABOVE In 1885, Tiffany & Co. were responsible for redesigning the Great Seal of the United States on the one-dollar bill, which remains unchanged to this day.

Tiffany & Co. has long been recognized as a key player on the sports field too. In 1877, it designed an interlocking NY for a police medal that was awarded to a wounded New York police officer. William Devery, co-owner of the New York Yankees and former Chief of Police, took the design and in 1909 it appeared on the Yankee uniform and can still be found on baseball caps worldwide. In 1888, Tiffany designed and crafted the Hall Championship Cup, the first sterling silver world championship baseball trophy, and has provided cups and trophies for the NFL since 1959 and the US Open for over 36 years, as well as for Formula 1, horse racing, golf, soccer, hockey and even e-sports.

BELOW Tiffany have been designing cups and trophies for the world of sport since 1888, from baseball (the Hall Championship Cup) and the NFL to the US Open and Formula 1.

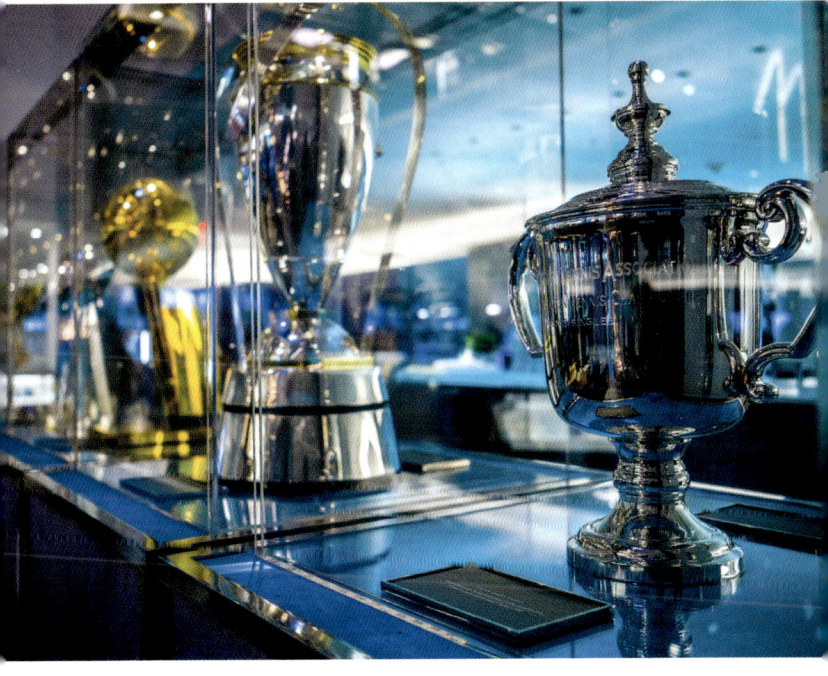

INTRODUCTION 11

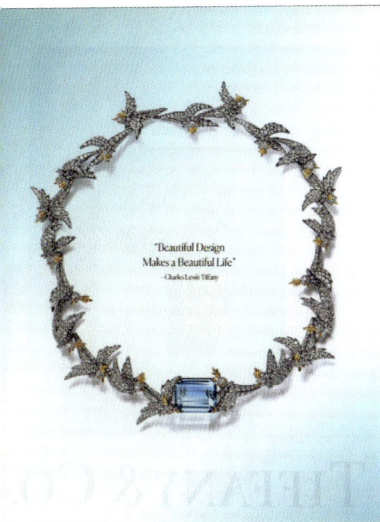

OPPOSITE From the late 1800s, Tiffany became known as "The Diamond Kings", a reputation that still stands. Diamond and 18k white gold brooch, circa 1950.

ABOVE Jean Schlumberger's diamond-encrusted Birds in Flight Necklace with an emerald-cut aquamarine and matching Bird on a Rock.

However, it was when Charles Lewis Tiffany bought one third of the French Crown Jewels at auction in Paris in 1887 that the company became known as the "Palace of Jewels" and he himself the "King of Diamonds". He went on to be appointed imperial and royal jewellers to kings, queens and czars around the world, from Europe to Russia. Indeed it was estimated that Tiffany's vaults held over $40 million in gemstones, a staggering sum for the late nineteenth century (with a value of more than $1 billion today).

Tiffany & Co. has stood the test of time thanks to innovation, creativity, shrewd business acumen, clever marketing and, most importantly, knowing its gemstones. Whether it's a vintage Elsa Peretti necklace found on eBay, a long-awaited engagement ring or a showstopping diamond, Tiffany jewellery is to be loved, treasured and handed down forever.

INTRODUCTION 13

THE
EARLY YEARS

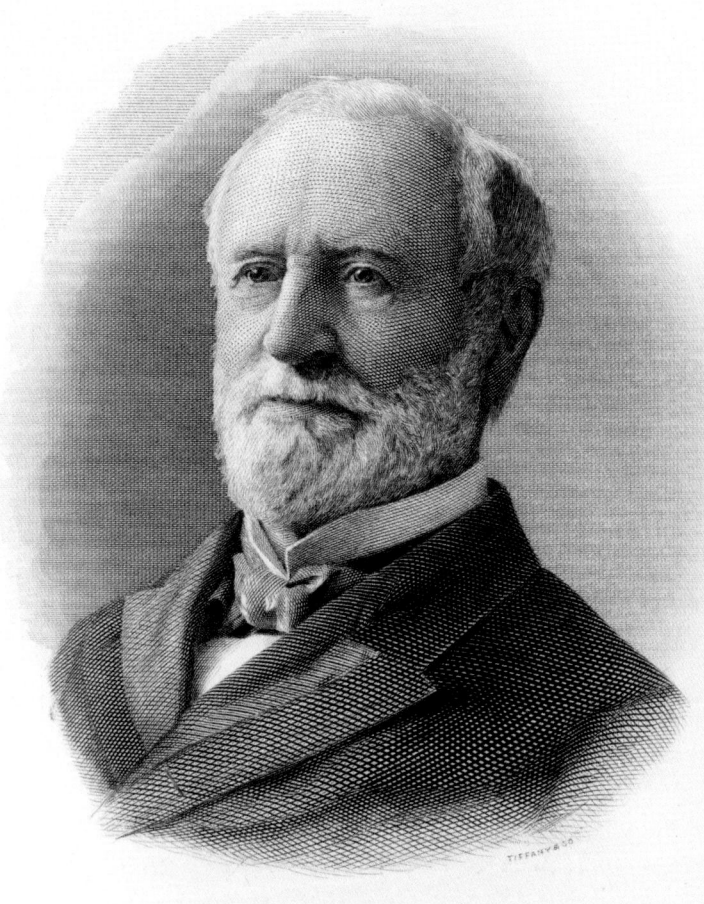

FROM "FANCY GOODS" TO "PALACE OF JEWELS"

"Beautiful design makes a beautiful life."
Charles Lewis Tiffany

On a mild autumn morning in September 1837, two friends, Charles Lewis Tiffany, age 25, and John Burnett Young, age 22, opened the doors of their small stationery and "fancy goods" store at 259 Broadway in lower Manhattan, New York, for the first time. Having each borrowed $500 from their parents, they sold an eclectic selection of bronze curiosities from India, delicate Chinese porcelain and the latest French accessories, all acquired from ships in New York returning from exotic locations around the world. There was not a diamond in sight. On that first day, they made $4.98.

OPPOSITE Charles Lewis Tiffany, who founded the small stationery and "fancy goods" store that went on to become the world-famous Tiffany & Co.

THE EARLY YEARS

In need of additional funding, the friends invited Charles's wealthier cousin, Jabez Lewis Ellis, to join them, and in 1841, the store became known as Tiffany, Young & Ellis. The extra capital allowed them to travel to Paris, where they discovered paste jewellery – known then as "Palais Royal" and today as costume jewellery – and this proved to be a huge success with their customers in the early 1840s. According to the Tiffany & Co. Archives, the first recorded order of goods from Paris on 1 December 1942 included fine stationery; Guerlain soaps and Lubin hair oils; vinaigrettes and smelling bottles; parasols for mourning, half-mourning and weddings; steel glove buttons, small pearl studs, jet jewellery, card cases and black fans. By 1843, solid gold jewellery was being added to their orders.

In 1845, Tiffany, Young & Ellis created the Catalogue of Useful and Fancy Articles, a yearly mail order catalogue that eventually became known as the Blue Book and which still continues today. It contained everything from shawl pins, dress combs, brooches and hair pins to board games, French sugar plums and gold and imitation "French jewellery".

Later that year, imitation jewellery was discontinued and only the real thing was imported from Paris and London. Tiffany, Young & Ellis was fast gaining a reputation for fine jewels for the rich society ladies of New York. At the same time, one of John Young's sisters became engaged to George McClure, a young and budding gemmologist, who joined the company and went on to become one of America's most respected names in diamonds and gemstones of his generation. By 1848, Tiffany, Young & Ellis were manufacturing their own jewellery.

Another stroke of luck came their way in 1848 when a buying trip to Paris coincided with the abdication of King Louis-Philippe. This caused panic and mayhem among the

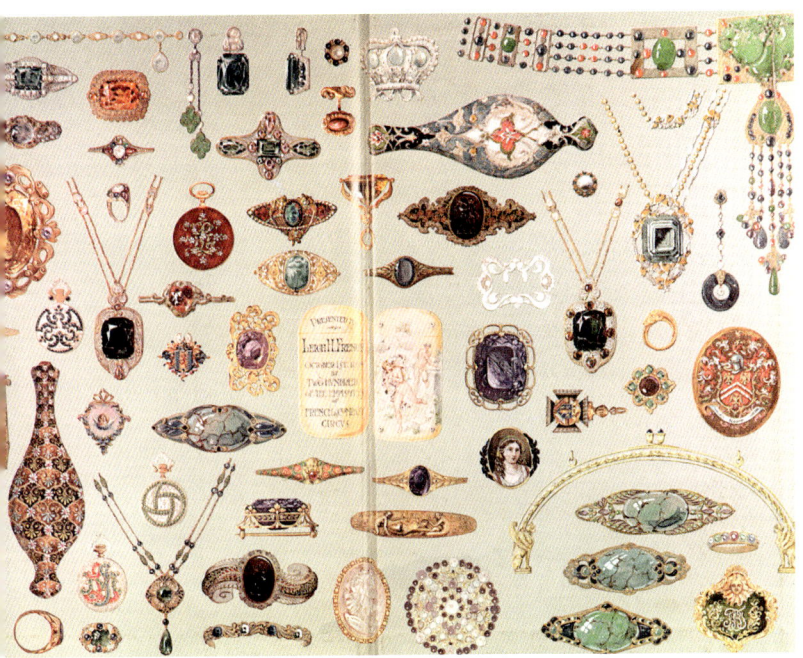

ABOVE A selection of brooches, pendants, rings and other bejewelled accessories from the 1890 Tiffany catalogue.

French aristocrats who, in fear of the forthcoming revolution, were desperate to sell off their stashes of diamonds and did so at rock-bottom prices. These were cleverly snapped up by John Young and diamonds immediately became an integral part of the business.

In 1853 Charles Tiffany bought his partners out and joined forces with a new partner, Gideon French Thayer Reed, a highly regarded American jeweller based in Paris. The company was renamed Tiffany & Co. They took the decision to exhibit at America's first world's fair, the New York Crystal Palace Exposition, which drew a global audience, sealing their reputation once and for all as a leading luxury retailer.

THE EARLY YEARS 19

STERLING SILVER

In the days before Tiffany & Co. became famous for diamonds and engagement rings, the store became world renowned for silverware. In 1851, it was the first to introduce the English sterling silver standard – a minimum of 92.5 parts per 1,000 parts; the remaining 7.5 parts are copper alloy, to strengthen the silver – which was later adopted by America in 1868.

After a successful collaboration the same year with leading silversmith John C. Moore, sales of sterling silver hit an all-time high. Following in his father's footsteps, Edward Moore became Tiffany's chief designer of silver in 1868, where he remained for the next 40 years.

LEFT Tiffany & Co. silverware advertisement in *National Geographic*, August 1927.

OPPOSITE An ornate Tiffany sterling silver tazza dish, dating between 1892 and 1902. These were particularly popular as tableware during the Gilded Age.

A great traveller and collector, Moore was inspired by Japanese lacquer, ceramics and baskets, Greek and Roman glass, and Islamic metalwork, glass, textiles and pottery. He created sterling silver "works of art" from tableware including jugs and pitchers, soup tureens, tea and coffee sets, monogrammed trays, cake stands, tea caddies, cutlery and napkin rings to hip flasks, candlesticks, cocktail stirrers, even asparagus serving forks.

As well as being an incredibly talented silversmith, Moore was a great mentor, and training the up-and-coming designers and silversmiths at Tiffany was an integral part of his work. He believed in sharing his knowledge and expertise as well as in collaboration, and when he died in 1891, he bequeathed his private collection to New York's Metropolitan Museum.

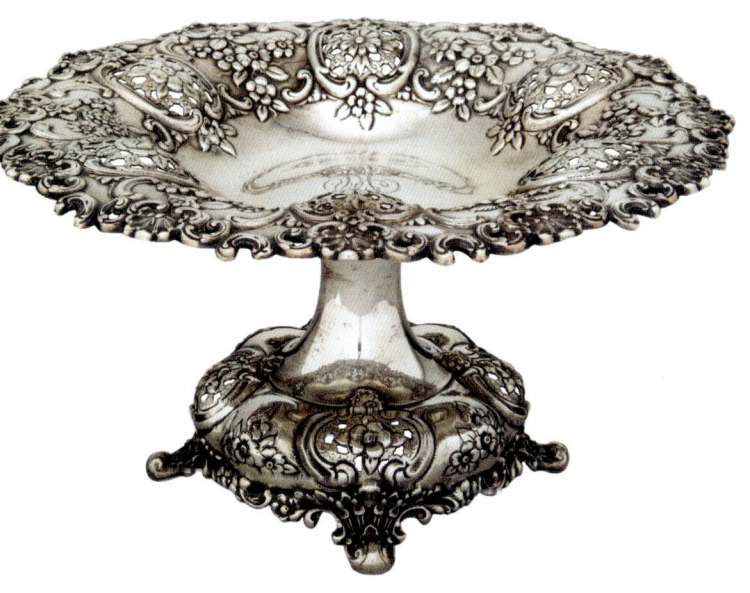

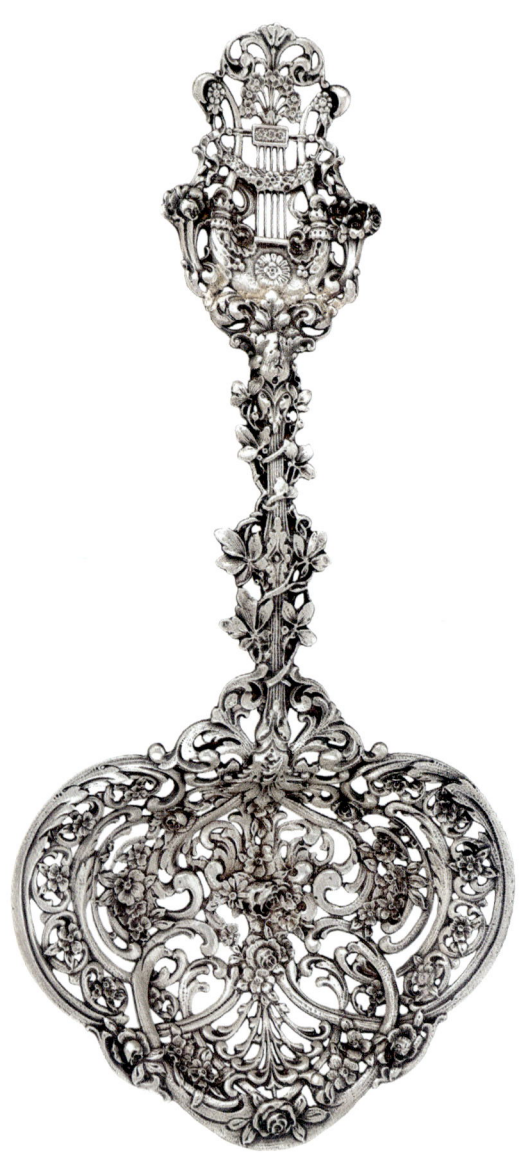

DIAMONDS AND PEARLS

OPPOSITE An intricate sterling silver bonbonnière spoon used to serve sweets, nuts and bonbons, dating from between 1891 and 1902.

BELOW By 1853 Tiffany & Co. were building a reputation for diamonds. Drop earrings with diamonds and emeralds set in palladium.

After gaining fame at the New York Crystal Palace Exposition in 1853, and other world fairs that followed, the world's wealthy socialites and royalty were sitting up and taking notice. By now Tiffany & Co. stocked a huge range of jewels, including silver, gold, diamonds and pearls.

In 1859 Tiffany were commissioned by Don Esteban Santa Cruz de Oviedo, a Cuban landowner and millionaire, to make a pearl and diamond parure (matching set of jewellery) for Frances Amelia Bartlett to mark their marriage, an event so ostentatious that it became known as the "Diamond Wedding". The necklace alone consisted of four strands of Orient pearls, looped into a lover's knot with a festoon of diamonds from which hung a single pear-shaped pearl.

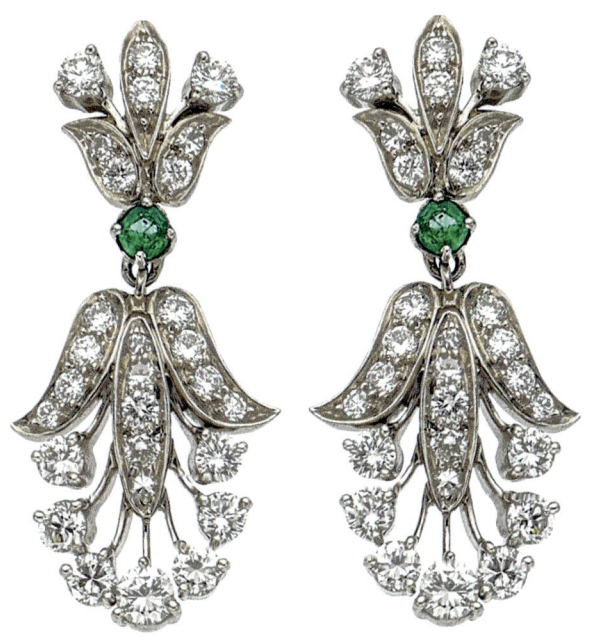

THE EARLY YEARS 23

The following year, one of New York's great social events was a ball held in honour of the Prince of Wales at the Academy of Music. In the seven days leading up to it, Tiffany sold more than $20,000 worth of diamond and pearl necklaces and pendants. One newspaper described the evening as "recklessly magnificent. The only jewels generally worn were diamonds, and these were in such profusion that the floor and the galleries sparkled like dew-laden banks of flowers in bright sunlight."

Despite a brief interlude during the American Civil War (1861–65), where Tiffany focused its energies on supplying entire regiments with rifles, cutlasses, bugles, cartridge boxes and surgical instruments, as well as presentation swords and medals for after the war, diamonds and pearls were still in high demand. So much so that Abraham Lincoln spent $530 on a gold and seed pearl parure of earrings, a necklace, brooch and bracelets for his wife, Mary Todd Lincoln, to wear at the Inaugural Ball on 4 March 1861. She loved the set so much that she wore it for many of her official portraits.

OPPOSITE Antique diamond and pearl brooch with Swiss diamonds, and four unique cream, lavender and pink natural pearls, each sourced from a different mollusc.

BELOW Designed by Paulding Farnham, this freshwater "dog-tooth" pearl and diamond chrysanthemum brooch was made for the American operetta star Lillian Russell in 1904.

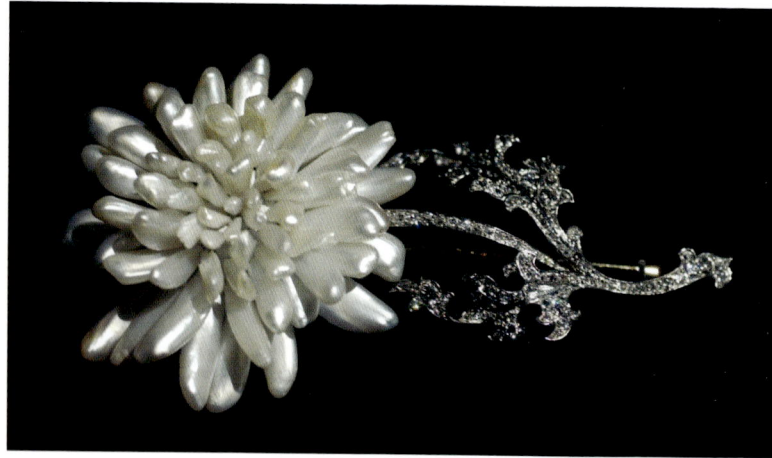

24 THE EARLY YEARS

THE GILDED AGE

The Gilded Age and the wealthy tycoons, industrialists, financiers and bankers that came with it could not have arrived at a better time for Charles Lewis Tiffany. With no aristocracy to base themselves on, this new American society wanted little to do with their European counterparts, other than their jewels. The conspicuous consumption of the burgeoning middle classes who craved opulence meant that acquiring luxury goods became their sole preoccupation.

While the women of this new prospering society needed to accessorize their extravagant gowns of the finest silks, tulle and lace with exquisite jewels and gems, sales of jewellery rocketed and Tiffany & Co., once again, were in the right place at the

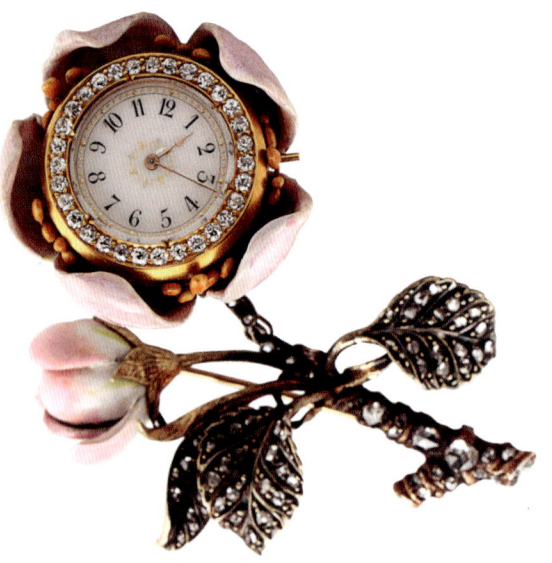

LEFT Exquisite women's lapel watch designed by Paulding Farnham in 1889, featuring pink enamel apple blossom and diamond-encrusted stem and leaves.

OPPOSITE The Bridgham family enjoying afternoon tea at home with a Tiffany & Co. sterling silver tea set. Like many families of the Gilded Age, they had homes in New York, Boston, Maine and Rhode Island.

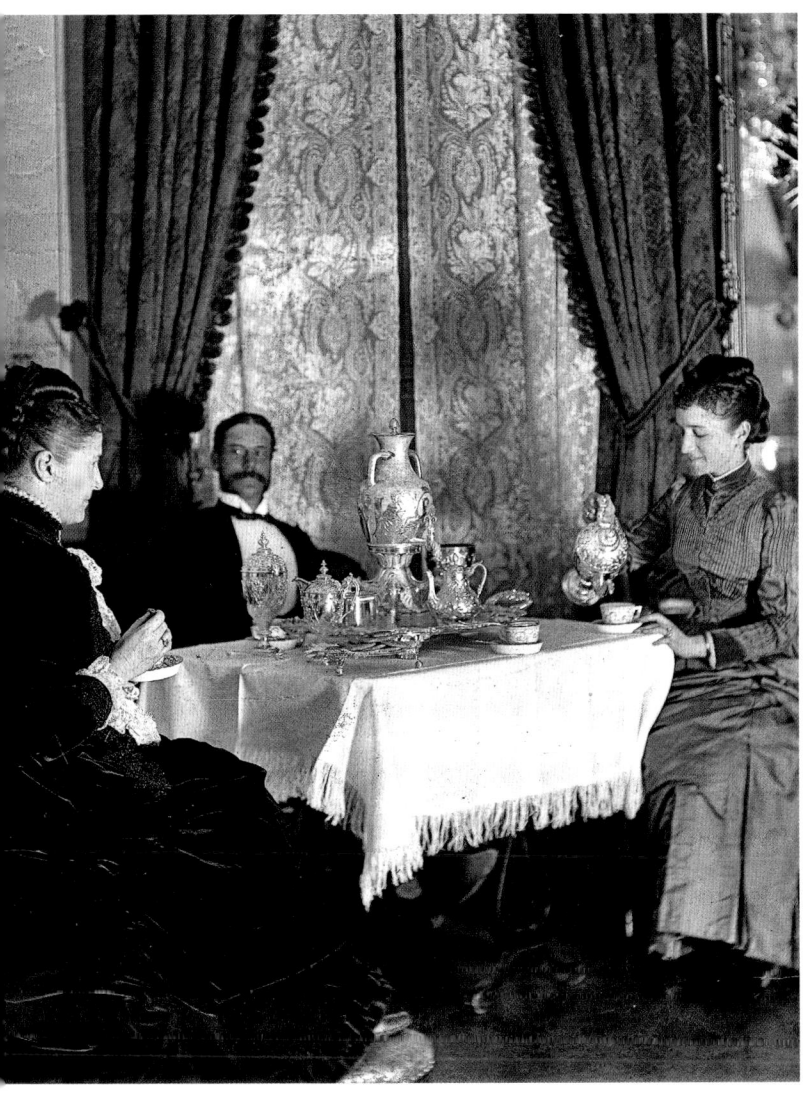

right time. According to John Loring, former design director at Tiffany and author of *Bejewelled by Tiffany*, you only had to look at the Tiffany & Co. ledgers of diamond purchases from the period to get a "tantalising glimpse" of who was buying what at the New York store, including the famous names of the times such as the Vanderbilts, Astors, Pullmans, Roosevelts and Stanfords.

Not one to be left behind, Charles embraced his new wealth by building one of the largest mansions of the Gilded Age on Madison Avenue. Completed in 1885, the mansion consisted of 57 rooms split into three separate residences for different Tiffany family members. The mansion was entered by walking through a huge stone arch leading to a central courtyard, with a tile roof so large that it could have easily covered a suburban railroad station, along with numerous turrets, balconies, chimneys and oriel windows. Some referred to it as the most artistic house in New York City while others felt it was conspicuous and ostentatious, which pretty much sums up what the author Mark Twain was describing in his novel that named this era: *The Gilded Age: A Tale of Today*, first published in 1873. Regardless, the mansion was a perfect reflection of the times and the success enjoyed by Tiffany & Co.

OPPOSITE A pioneer of the Gilded Age, Charles Lewis Tiffany had a 57-room mansion designed by the then fashionable architect Stanford White at 72nd Street and Madison Avenue, New York.

KING OF DIAMONDS

In 1878 one of the most famous sales of royal jewellery took place, when the jewels of Isabella II, Queen of Spain, came to market. Tiffany & Co. was one of the main buyers but the real coup, and yet another stroke of luck, came in the spring of 1887. This was the height of the Gilded Age and Tiffany & Co. knew the wants and desires of their wealthy customers almost better than they did. The French government had decided to sell off the French Crown Jewels at auction. This was a controversial decision as many felt that the jewels were part of the fabric of French history and should be kept, but the sale was announced for 12–23 May. The jewels, stored in the basement of the Ministry of Finance, were crudely broken up into lots.

Charles Lewis Tiffany quietly swept up 24 lots – one third of the total – including four ropes of large round diamonds from Empress Eugénie's devant de corsage or stomacher – a piece of jewellery worn on the centre panel of the bodice of a dress. Later that same afternoon, he sold it to the publishing mogul Joseph Pulitzer, whose wife wore it to a Paris ball that evening. This swift and clever transaction earned Tiffany the unofficial name of the "King of Diamonds", and it was a deserving title.

By summer the wealthy women of the Gilded Age were dripping in Empress Eugénie's coveted jewels. American heiress Cornelia Bradley Martin bought two diamond and ruby bracelets made for the Duchess of Angoulême, the niece of Charles X; an 8.84-carat briolette diamond bought by Louis XVIII in 1818 caught the eye of Katherine May Safford, the former daughter-in-law of Andrew Johnson, the man who became president following the assassination of Abraham Lincoln; banker and financier Junius Spencer Morgan

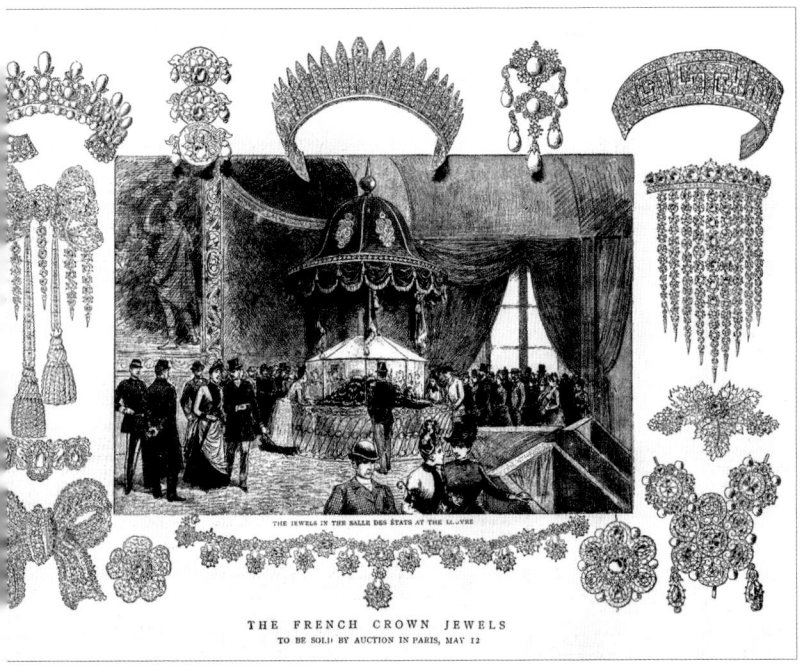

THE FRENCH CROWN JEWELS
TO BE SOLD BY AUCTION IN PARIS, MAY 12

ABOVE Charles Lewis Tiffany purchased one third of the French Crown Jewels in Paris in May 1887. This illustration shows a selection of the jewels on offer at the auction.

purchased 28 diamonds from Eugénie's great diamond combs and New York socialite Caroline Schermerhorn Astor snapped up Empress Eugénie's diamond currant-leaf corsage ornaments.

By the end of the century not only was Tiffany & Co. known as the "Palace of Jewels" or "The Diamond Kings", but they were also appointed the imperial and royal jeweller, goldsmith and silversmith to royalty across the globe from Queen Victoria, the Czar and Czarina of Russia, the Emperor of Austria, King of Prussia, King of the Belgians, and the kings of Italy, Greece, Denmark, Spain, Portugal and Romania.

THE EARLY YEARS 31

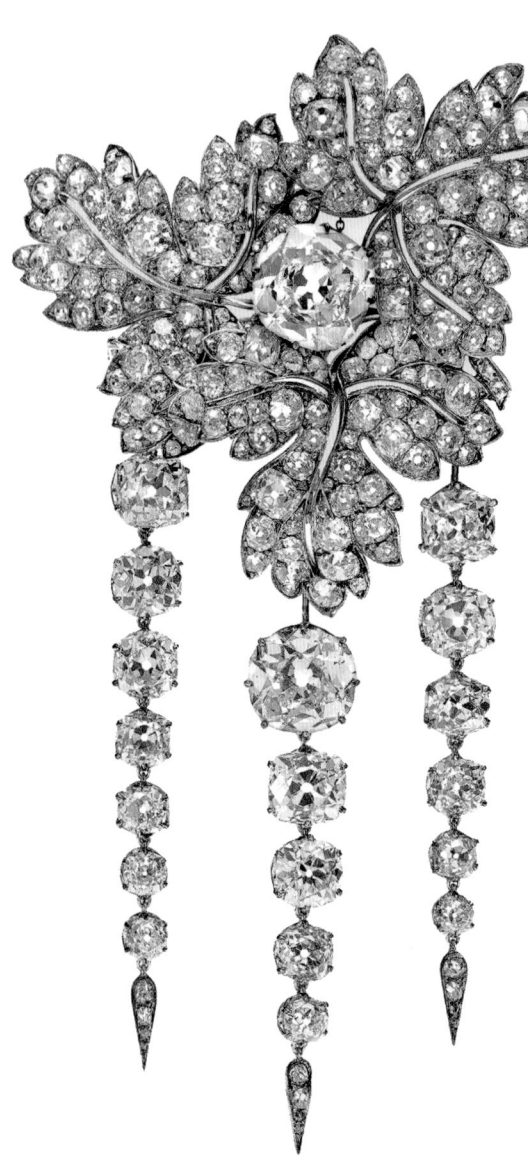

LEFT A diamond *feuilles de groseillier* brooch taken from a huge "garland of currant leaves" belonging to the Empress Eugénie in 1855. The brooch was part of lot 11 and purchased by Tiffany at the auction of the French Crown Jewels.

OPPOSITE Portrait of Empress Eugénie in happier times on the day of her wedding to Napoleon III. Her tiara contained an incredible 212 pearls and 1,998 diamonds.

32 THE EARLY YEARS

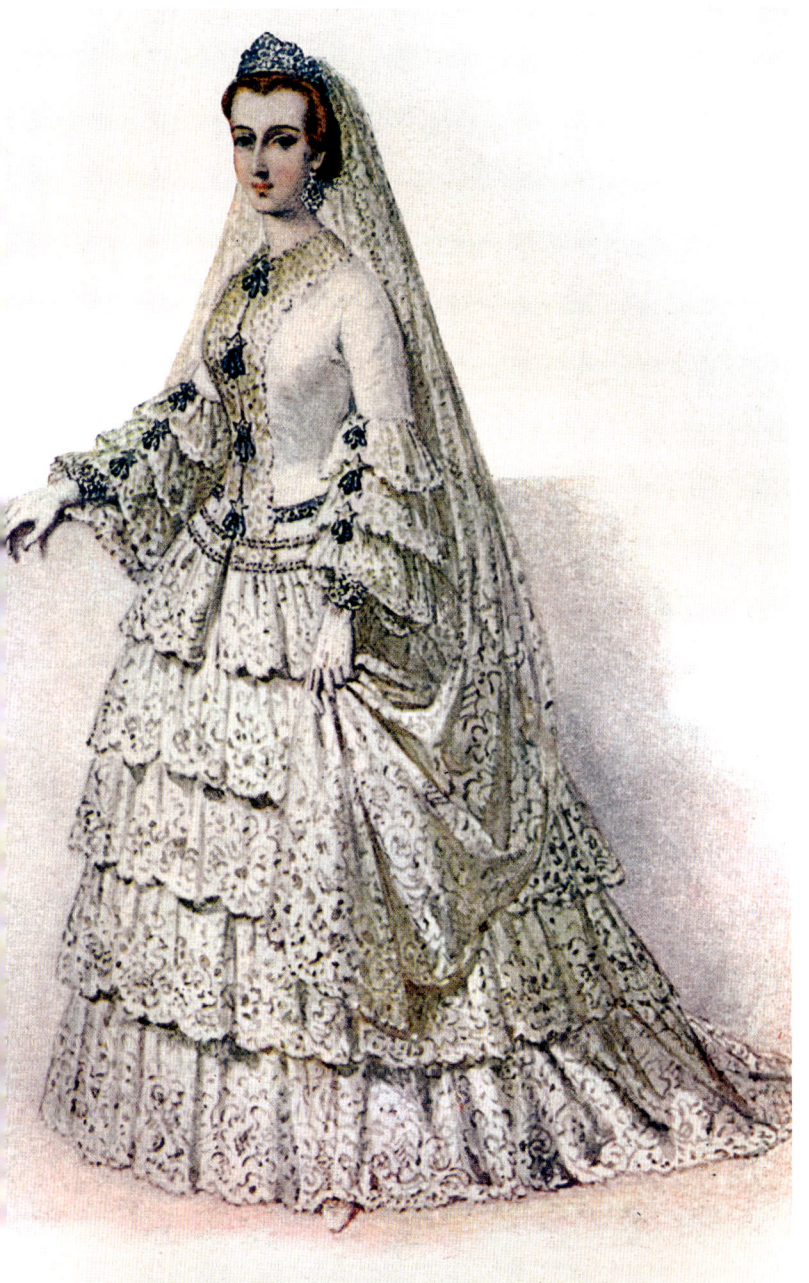

THE TIFFANY DIAMOND

ALL THAT GLITTERS

"It isn't that I give a hoot about jewellery, except diamonds of course. Like that!"
Holly Golightly, *Breakfast at Tiffany's*

In 1877 Tiffany exhibited a diamond peacock feather aigrette, or headdress, set with more than 600 diamonds with a lemon-yellow diamond in the centre. The 30-carat Brunswick diamond, as it was known, had been purchased from the Duke of Brunswick in 1874, and the aigrette was hailed as the first great "designed" piece of jewellery from Tiffany & Co.

However, no sooner had the newspapers caught on to the magnificence of this diamond than it was pipped to the post by the largest canary-yellow diamond ever found. Discovered in a South African diamond mine in 1877, the 287.42-carat rough stone was purchased by Charles Lewis Tiffany for $18,000 the following year. He took it to his chief gemmologist in Paris at the time, George Frederick Kunz, who studied it for a year before cutting it into a brilliant-cut, cushion-shaped, 128.54-carat finished diamond with 82 light-reflecting facets, rather than the more traditional 58. *Vogue* referred to it as "128.54 carat of pure crystallized sunlight" and it was named the Tiffany Diamond.

OPPOSITE To celebrate Tiffany designer Jean Schlumberger, at the Musée des Arts Décoratifs in Paris in 1995, a brand-new version of his 1965 Bird on a Rock was unveiled, featuring the diamond bird mounted onto the legendary Tiffany Diamond.

Nearly one and a half centuries later, the Tiffany Diamond has been through many incarnations and has been exhibited around the globe but has been worn in public by only four women. The first was New York socialite Mary Sheldon Whitehouse, who wore it for the Tiffany Ball on 13 July 1957. The diamond was then reset into the Ribbon Rosette necklace in 1960 by Tiffany jeweller Jean Schlumberger, famously making its first appearance on screen the following year.

What is less well known is that four years previously, Jean Schlumberger had, in fact, designed a Wardrobe of Settings so that the canary yellow diamond could be worn interchangeably in three different settings, which was described in *Vogue* (15 November 1956). The first (as worn by Mary Sheldon Whitehouse) was a pendant with the stone entwined by platinum and gold ribbons set with white diamonds. The second was a winged clip of platinum and white diamonds with small gold flames flickering around the central stone, and the third, a platinum and white diamond bracelet with the Tiffany Diamond set in the middle and ringed by daisies with gold-tipped petals and gold-edged hearts.

In the 1961 film *Breakfast at Tiffany's*, Audrey Hepburn's Holly Golightly, dressed in a Givenchy orange coat and mink hat, walks through the revolving doors at Tiffany's with George Peppard. Insisting that she doesn't "give a hoot about jewellery, except diamonds of course", she passes a display cabinet. "Like that!" she adds, pointing to the Tiffany Diamond necklace. Golightly wears no Tiffany jewellery in the film, but Hepburn did wear the necklace in publicity images.

In 1995, the Musée des Arts Décoratifs in Paris honoured Jean Schlumberger with an exhibition "Une Diamant dans la Ville" ("A Diamond in the City"), and Tiffany celebrated by unveiling a brand-new version of the designer's Bird on a

OPPOSITE The Tiffany Diamond mounted in a necklace of white diamonds weighing over 100 carats. It was worn by Lady Gaga in 2019 and Beyoncé in 2022.

THE TIFFANY DIAMOND

LEFT Although she didn't wear any Tiffany jewellery in the actual film, Audrey Hepburn did wear Jean Schlumberger's elaborate Ribbons necklace starring the Tiffany Diamond in her publicity shots for *Breakfast at Tiffany's*.

Rock, which had previously been launched in 1965, inspired by a yellow cockatoo and his home of Guadalupe. This time, however, the diamond-encrusted bird was mounted onto the legendary Tiffany Diamond.

It wasn't until 2012 that the diamond was reset again to celebrate Tiffany's 175th anniversary. This time, the precious jewel was suspended from a necklace set with white diamonds weighing over 100 carats. It was next worn by Lady Gaga on the red carpet at the 2019 Oscars where she claimed that she accidentally left the after-party with the necklace still on and her car had to be pulled over by Tiffany security, who

40 THE TIFFANY DIAMOND

RIGHT Lady Gaga wore the Tiffany Diamond necklace at the Vanity Fair Oscar Party in 2019 and paired it with yellow and white diamond earrings that mirrored its design.

very politely removed it from her neck. Most recently, in 2022, Beyoncé was the next – and, to date, the last – wearer of the Tiffany Diamond as part of the Lose Yourself in Love advertising campaign, with husband Jay-Z.

In 2023, the diamond went through yet another incarnation in celebration of the reopening of The Landmark, Tiffany & Co.'s flagship store on Fifth Avenue. Based once again on Jean Schlumberger's Bird on a Rock and created over a span of nearly 2,000 hours, the canary yellow diamond now hangs from a diamond necklace, nestled among five individually designed diamond-encrusted birds that flutter around it. Who knows what and when the next metamorphosis will be?

THE TIFFANY DIAMOND 41

BLOOMS
AND
BOTANICALS

TIFFANY AND NATURE

"Beauty is what nature has lavished upon us as a supreme gift."
Louis Comfort Tiffany

As early as 1858, floral themes began to emerge in Tiffany's jewellery collections. Fashionable in Europe, the trend was embraced by New York, and Tiffany satiated their customers' appetite with an array of brooches featuring diamond dahlias, rosebud sprigs, ruby and diamond bouquets of violets, pearl acorns with diamond leaves and bejewelled almonds and pineapples. There were earrings scattered with diamond rosebuds or fuchsias, and rings with tiny ruby and diamond forget-me-nots.

However, it was young jewellery designer Paulding Farnham who truly put flowers on the map for Tiffany, first with his collection of orchids, which was followed by an array

OPPOSITE Model and actress Angelbaby wears Jean Schlumberger for Tiffany Sea Life Necklace with diamonds, emeralds and sapphires at the reopening of The Landmark, Tiffany's refurbished flagship store on Fifth Avenue, in April 2023.

RIGHT Floral themes were popular in jewellery from the mid-1800s: blue and green enamel flower brooch with diamonds set into 18k gold.

BLOOMS AND BOTANICALS 45

of rose branch brooches, diamond floral sprays, diamond-encrusted carnations, freshwater pearl and diamond chrysanthemums, and even dandelions. When Louis Comfort Tiffany took over from his father in 1902, the nature theme continued with grapevine necklaces, dragonfly brooches and wildflower belt buckles to name but a few.

When designer Jean Schlumberger joined in 1956, he followed with diamond- and gem-encrusted flowers, birds, sea life and shells, fruits and berries, mythical creatures and insects. His birds, butterflies and sea creatures are still part of Tiffany's high jewellery collection today. The theme continued throughout Jean Schlumberger's long tenure at Tiffany, followed by designers Donald Claflin and Angela

ABOVE This unique antique dragonfly brooch with enamel, sapphires, diamonds, opals and emeralds has an articulated tail that can be moved, breathing life into this beautiful piece of jewellery.

46 BLOOMS AND BOTANICALS

Cummings, both of whom created numerous nature-inspired pieces, from flower and bug necklaces to belts festooned with sea dragons, gold and copper necklaces of autumn leaves and diamond necklaces that resemble melting snowflakes. In 1974, Elsa Peretti joined Tiffany and added her passion for bones, skeletons and other natural objects to the mix, all of which are still bestsellers for Tiffany.

RIGHT Tiffany & Co. 1966 advertisement for Jean Schlumberger's sea life-inspired jewellery featuring fish, starfish, coral and shells encrusted with diamonds, emeralds and sapphires.

BLOOMS AND BOTANICALS 47

48 BLOOMS AND BOTANICALS

THE TRIUMPH OF ORCHIDS

In 1875, at the tender age of 16, Paulding Farnham, whose uncle, Charles T. Cook, was vice president at Tiffany's, began working for the company as an apprentice and showed great promise right from the beginning. Nearly 15 years later, he exhibited 24 life-size Orchid Blossom brooches at the Paris Exposition Universelle of 1889, which catapulted him to fame.

The orchids were so close to the real thing that it seemed almost unbelievable that they had been created by a jewellery house – nothing like it had ever been seen before. After studying and sketching many different orchid varieties from Burma, the Philippines, Brazil, Ecuador, Peru and Columbia, Farnham created brooches that were each an exquisite work of art.

OPPOSITE One of Jean Schlumberger's most recognizable designs is the Dolphin Brooch with round-cut sapphires and garnets, diamonds and ruby gemstones set in platinum and 18k gold.

RIGHT A rare example of Paulding Farnham's 24 lifelike orchid brooches that Tiffany exhibited at the 1889 Paris Exposition, winning the company a gold medal, the first such award ever achieved by an American firm.

BLOOMS AND BOTANICALS 49

The three-dimensional flowers were enamelled onto gold, and their stems and delicate stamens – some as fine as a strand of hair – encrusted in diamonds and gemstones. The *Paris Herald* claimed the orchids exhibition to be the "greatest triumph… They are so faithfully reproduced that one would almost doubt that they are enamel, so well do they simulate the real flowers."

For Tiffany & Co. the timing could not have been better. In the late 1880s, many wealthy Americans were keen orchid collectors, often going to extortionate expense to have them imported from nurseries in London. Only a few years before, an auction of orchids in New York had seen individual plants selling for as much as $900, almost $30,000 in today's money. Even before Tiffany's orchids had reached Paris, the railroad magnate and avid orchid collector Jay Gould had purchased several.

ABOVE Paulding Farnham's enamelled orchid in white, red, chartreuse and yellow. Based on the *Oncidium jonesianum* species from Paraguay, the flower and stem are embellished with diamonds.

Following the success of the orchids, there was a huge demand for Paulding Farnham's enamelled floral jewellery, from pansies and roses to delicate sprigs of lilac, and the theme continued until 1908 – but it wasn't to last. In 1902, Charles Lewis Tiffany died and his son, Louis Comfort Tiffany, became the first official design director of Tiffany & Co.

It soon became clear that there was room for only one talented designer at the company, and the only contender was the man who was both the design director and a holder of the Tiffany name, Louis Comfort Tiffany. Four years later, Paulding Farnham resigned and his sketchbooks were put away in a storeroom. Often referred to as the "Lost Genius", he will always be remembered as one of America's greatest jewellers of all time, and his orchids, as rare as the real thing, occasionally come up at auction, commanding prices of up to $500,000.

BLOOMS AND BOTANICALS 51

LOUIS COMFORT TIFFANY

Before joining Tiffany & Co., Louis Comfort Tiffany was a well-known artist and designer in his own right. A pioneer of the art nouveau movement of the late 1800s, he became famous for his Tiffany style and Favrile glass – a glass-blowing technique known for its iridescence and brilliant colours. He earned countless accolades for his work, including a series of 11 stained-glass windows, consisting of 58 panels, for the Brown Memorial Presbyterian Church in 1905, along with windows and panels in numerous churches and cathedrals, banks, hospitals, department stores and hotels.

In 1882 President Chester Arthur commissioned him to redecorate several State Rooms at the White House. He tinted the walls of the Blue Room in a light "robin's egg blue", which became lighter towards the ceiling and culminated in an ivory and silver frieze of hand-pressed paper, and also designed the snowflake-like lights that adorned the walls.

OPPOSITE Even before joining Tiffany & Co., Louis Comfort Tiffany was famous for his stained-glass windows, such as this work of art with magnolias and irises created in 1908.

BELOW Louis Comfort Tiffany was renowned for his love of nature and the colourful and iridescent Favrile glass, also known as "Tiffany Style" glass.

52 BLOOMS AND BOTANICALS

Probably most recognizable, even today, are his decorative Tiffany lamps, which were produced by his company, Tiffany Studios. These were designed by himself and his right-hand woman, Clara Driscoll, who was at his side for 20 years, and then were created by her team of 35 "Tiffany Girls", who produced some of Tiffany's most famous lamps, mosaics, windows and decorative objects. Clara wrote in her notes that she designed the famous Daffodil Lamp during her lunch hour, one of which sold for $2.1 million at Sotheby's New York in 2015.

Louis was one of the first designers to recognize the potential of electric lighting – the Tiffany factory became the first of its kind to be entirely operated by electricity – and with his team he created hundreds of designs, but most notable is that invariably he chose natural motifs, including everything from fruits and flowers such as peonies, daffodils, apple blossom and tulips to lily pads, dragonflies and other insects, a theme that stayed with him throughout his whole professional career.

Louis's arrival at Tiffany & Co. and the world of jewellery was no different. He unveiled his first 27 designs at the Louisiana Purchase Exposition in St Louis in 1904 and his audience was not disappointed. With most pieces based on plants and wildlife, these included an exquisite dragonfly and dandelion hair ornament; butterfly brooches with shimmering sapphire wings; a grapevine necklace in gold and enamel leaves scattered with opal grapes; and a hair ornament in silver, copper and enamel with tiny clusters of opals and garnets to mimic cow parsley, otherwise known as Queen Anne's lace, a wild plant that was his frequent inspiration.

As an established painter, and inspired by his travels to Egypt and North Africa, Louis was passionate about colour – which he was able to express through his choice of gemstones.

OPPOSITE The Wisteria Lamp, designed by Clara Driscoll in 1901, was one of Tiffany's most famous glass lamps. Each one was handmade with nearly 2,000 glass tiles, each selected for their colour, pattern and iridescence.

Vine leaves and grapes were adorned with opals, amethysts and nephrite; gold berries with black opals and garnets; sea plants with moonstones and sapphires; and flowers with pearls and diamonds.

For 30 years Tiffany & Co. enjoyed huge success led by Louis Comfort Tiffany, who worked alongside a team of talented designers. However, when the First World War broke out in 1914, art nouveau lost its appeal and by 1918, the Jazz Age hailed the arrival of art deco. With its geometry and simplicity, this was not a style that Louis favoured at all and in 1924 he left Tiffany & Co. and closed his glass business. Art nouveau was well and truly over. On 17 January 1933, Louis died and his jewellery department at Tiffany & Co. was closed. The vibrant colours and unique nature-inspired designs that had made Tiffany's such a success in the late 1800s and early 1900s would not be seen again until the arrival of Jean Schlumberger in 1956.

LEFT Louis Comfort Tiffany exhibited this hair ornament inspired by Queen Anne's lace at the Saint Louis Exposition in 1904. One of three representing varying stages of bloom, it features tiny opals, garnets and enamel florets to show the flower in full bloom

OPPOSITE One of the earliest examples of jewellery by Louis Comfort Tiffany, this grapevine necklace is embellished with iridescent opals and enamel in shades of green to resemble clusters of grapes and leaves.

56 BLOOMS AND BOTANICALS

BLOOMS AND BOTANICALS 57

FROM
BROADWAY
TO
FIFTH
AVENUE

TEMPLE OF FANCY

"I don't want to own anything until I find a place where me and things go together. I'm not sure where that is but I know what it is like. It's like Tiffany's."

Holly Golightly, *Breakfast at Tiffany's*

When Holly Golightly walks into Tiffany & Co. on Fifth Avenue in *Breakfast at Tiffany's*, you can almost smell the glass polish and expensive perfume. The dim lighting and hushed tones give it a sense of quiet refinement and dignity. When Holly exclaims: "Of course, I don't know what I'm going to find at Tiffany's for $10" and asks to have a free ring from a Cracker Jack box of popcorn engraved, the salesman gently replies: "I think you'll find that Tiffany's is very understanding."

OPPOSITE Holly Golightly in *Breakfast at Tiffany's*, gazing longingly into the window of Tiffany & Co. on Fifth Avenue in the opening scene of the film.

Tiffany's has always been as much about the experience as the jewellery itself – in 1875 the *New York Evening Post* called it a "Temple of Fancy" – and that's exactly what Charles Lewis Tiffany and John Young set out to achieve. Back in 1845 when Tiffany, Young & Ellis launched their first Catalogue of Useful and Fancy Articles, it stated, "As their establishment is the largest of its kind in the country (if not in the world) and has become one of the attractions of the city, they respectfully invite the visits of strangers, under the assurance that they may examine the collection without incurring the least obligation to make purchases."

At the same time, Charles Lewis Tiffany knew what was required when it came to Tiffany's wealthiest customers. He had seven members of staff whose sole job was to keep detailed files on the wealthy socialites across America. Everything from photographs, newspaper and magazine cuttings and details of their finances were kept at hand so that when they walked

ABOVE One of *Breakfast at Tiffany's* most famous scene with Holly Golightly (Audrey Hepburn) and Paul Varjak (George Peppard) scanning Tiffany's display cases, looki for something under $10.

OPPOSITE Tiffany & Co. is as famous today for its sparkli gemstones as it was in the 1800s. This diamond and platinum Jazz necklace is a perfec example of the art deco period.

62 FROM BROADWAY TO FIFTH AVENUE

through the doors, they were instantly recognized, addressed by name and given immediate credit. Charles recognized that in making these customers feel unique and valued, he would keep them forever. The strategy worked.

Ultimately though, of course, it was the jewels that made Tiffany's a household name across the globe. Diamonds were not commonplace in America until John Young returned from Paris in 1848 with his stashes of bargain-priced diamonds purchased from French aristocrats desperate to make money in this Year of Revolution. Wealthy Americans couldn't get enough of Europe's glistening status symbol and the more diamonds Tiffany's acquired, the more their appetite grew. And it didn't stop there. Pearls, particularly freshwater pearls from American rivers and rare pink pearls from conch shells, gained in popularity, along with a huge palette of colourful gemstones, thanks to jewellery designers Paulding Farnham and Louis Comfort Tiffany.

What makes Tiffany's special, and is certainly part of its historic success, is that it has never shied away from its original ethos. Even today you can walk into a store and find something for the equivalent of Holly Golightly's $10 (about $105 in today's money), from an Elsa Peretti sterling silver bookmark or heart-shaped crystal paperweight to a heart pendant charm in sterling silver – or you can simply browse and soak up the atmosphere.

FROM BROADWAY TO FIFTH AVENUE 63

AN AMERICAN INSTITUTION

From the small stationery and "fancy goods" store at 259 Broadway, Charles Lewis Tiffany moved his store three times over the next three decades. The stores were larger and grander with each move, firmly establishing Tiffany & Co. at the pinnacle of luxury retailers in New York. In 1905, three years after Charles's death, the Tiffany store moved to 401 Fifth Avenue. Though the thoroughfare is now considered the epitome of luxury, it had not yet become fashion's most prestigious address.

Even so, by this point Tiffany & Co. knew that it should have a building that matched the glamour of its now world-renowned brand. And the company didn't disappoint. Architects McKim, Mead & White were appointed to design the new building, based on the sixteenth-century Venetian Palazzo Grimani, which was described by the novelist Henry James as "a great nobleness of white marble". Today, *The Architectural Guidebook to New York* draws attention to the "phenomenal lightness to this building that is an almost perfect amalgam of the Beaux-Arts and the Modern."

The building was Tiffany's home throughout the First World War, the Jazz Age and the era of art deco, and the Great Depression of the 1930s. Sales increased from $7 million in 1914 to $17.7 million in 1919, and even though these figures were rarely matched throughout the 1920s, profits and dividends remained comfortably high.

OPPOSITE In 1905, based on the sixteenth-century Venetian Palazzo Grimani, Tiffany's new store at 401 Fifth Avenue set a precedent for this up-and-coming area of New York.

THE GREAT DEPRESSION

Despite not having a well-known and established jewellery designer at the time, Tiffany's embraced the art deco era with aplomb and the 1920s saw geometric pendants and bracelets in platinum encrusted with baguette-cut diamonds and "Columbian emeralds as big as sugar cubes"; architectural-style diamond necklaces depicting the skyscrapers that were being built across New York at the time; and stylized gold, diamond and sapphire make-up cases (one of which was gifted to Elizabeth II for her Diamond Jubilee in 2013 by President Obama and First Lady Michelle).

However, the Wall Street Crash of October 1929 proved devastating, especially for Tiffany & Co. In the Great Depression that followed, the wealthiest were hit hard. On Black Thursday, 24 October, the stock market lost 11 per cent of its value – still the largest sell-off of shares in American history. To cater for its customers who still wanted to wear

ABOVE Huge emeralds were popular during the art deco period – and Tiffany, always one step ahead of their customers, embraced the trend. Art deco emerald, diamond and platinum ring.

66 FROM BROADWAY TO FIFTH AVENUE

jewellery but no longer had the budget for the extravagant jewels of the last 50 years, Tiffany's had to be content with sales of gold jewellery set with inexpensive semi-precious stones or small diamonds, rubies or emeralds, while the fine jewellery of the late 1920s sat collecting dust in the basement.

As the rich cut back on luxury goods, Tiffany's sales fell by 45 per cent in 1930, another 37 per cent the following year, and yet another 45 per cent in 1932 when the federal government imposed a tax on jewellery. By that point, annual sales were $2.9 million – paltry by its usual standards. Fortunately, the company had been shrewd during its more affluent times and was able to dip into its capital reserves, enabling it to soldier on through the next decade. However, despite all the doom and gloom, another big move was on the horizon.

BELOW Coined "New York's Crown Jewel", Tiffany's flagship store at 727 Fifth Avenue was completely refurbished and reopened as The Landmark in April 2023. Advertisement from the *New Yorker*, May 2023.

TIFFANY & CO.

THE LANDMARK

Just as the Second World War was breaking out in Europe, Tiffany & Co. moved for the last time to 727 Fifth Avenue, on the corner of Fifth Avenue and 57th Street. Considered to be the most prestigious real estate site in New York at the time – and to this day – and designed by architects Cross & Cross, the seven-storey building cost $2.5 million to build and featured a façade of pink granite, limestone and marble with bands of continuous vertical windows. Not only was it considered to be the height of modern architecture, but it was also the first fully air-conditioned building in New York.

Above the entrance stands the famous Atlas clock that had originally been mounted above the Tiffany store on Broadway. Commissioned in 1853 by Charles Lewis Tiffany, it was made by his friend Henry Frederick Metzler, a carver of ship figureheads, and now travelled with the company to the new flagship. Standing 2.7m (9ft) tall, Atlas holds a large clock, and had by this point become a site so familiar it instantly identified the brand-new store, which opened for business on 21 October 1940.

In the summer of 1945, a young university student named Marjorie Hart and her friend, Marty, arrived in New York, looking for a summer job. Having been turned down by department store Lord & Taylor, they found themselves nervously entering the revolving doors at Tiffany & Co. "Inside, it was cathedral-like: spacious, serene, and cool. On the panelled main floor, marble-framed mirrors reflected the light from the windows on the opposite wall. Diamonds shimmered from glass counters as if they were alive, while solemn, dignified men watched over them like sentinels," remembered Marjorie in her book, *Summer at Tiffany*.

OPPOSITE The Tiffany & Co flagship store on Fifth Avenue was opened October 1940 and the famous Atlas clock, commissioned Charles Lewis Tiffany in 1853, travelled to the new store where it still stands today.

FROM BROADWAY TO FIFTH AVENUE 69

Their awe quickly turned to disappointment when they were told, "At Tiffany, we only have salesmen on the floor". As luck would have it, though, the war meant there was a shortage of men and the store needed "pages", who delivered packages to the repairs and shipping departments. Thrilled with their $20 a week, they then became the first women to be employed on the sales floor and Marjorie wrote to her parents exclaiming, "*Thrilled* to pieces! We have the job at *Tiffany's*!!! Can you believe it?"

The building remained virtually the same until an additional upper structure to house office space was added to the top of the building in 1980. And then, in 2023, 727 Fifth Avenue underwent a complete transformation and was renovated from top to bottom.

Now referred to as The Landmark, the façade remains relatively unchanged. The interior is a different story and now consists of 10 floors where lavish and luxurious jewels

ABOVE Jean Schlumberger jewellery nestles among an elaborate festive feast fit for a king in the holiday window of Tiffany in November 2016.

ABOVE RIGHT
The Landmark's
sculptural spiral
staircase crafted
of cerused oak
with transparent
balustrades, to
reflect the natural
and sensual designs
of Tiffany designer
Elsa Peretti.

rub shoulders with pieces of priceless art from names such as Damien Hirst and Jean-Michel Basquiat. The main floor, with its white marble and sculptural spiral staircase, houses "Diamond Skylight", a 6.7m (22 foot) rectangular art installation by Hugh Dutton, and has gold leaf incorporated into the grains of the wooden flooring. There is a floor dedicated purely to "love and engagement" as well as workshops and a restaurant, but the pièce de résistance has to be the "The Jewelry Box", a three-storey glass exhibition and events space on the top of the building which not only has panoramic views of New York City but is lit at night in Tiffany Blue.

FROM BROADWAY TO FIFTH AVENUE 71

THE GREATEST SHOWMAN

One of Tiffany & Co.'s best-kept secrets was Gene Moore, window-dresser extraordinaire, who joined the company in 1955 and created more than 5,000 displays over the next 39 years while also revolutionizing the art of window displays.

He had already made his mark at two of New York's most prestigious department stores, Bergdorf Goodman and Bonwit Teller, and now, according to the Smithsonian Institute archives, he was presented by Tiffany chairman Walter Hoving with the following mission: "I want you to make our windows as beautiful as you can according to your own taste... Above all, don't try to sell anything; we'll take care of that in the store."

And he did not disappoint. By combining everyday objects – leaves, flowers, fruit, eggs, string, household tools, sand, even broken glass – with exquisite pieces of jewellery, along with clever lighting and shadow, Moore created fantastical and whimsical displays unlike anything that had been seen before. He was quoted as saying, "When someone looks into a Tiffany window, I want them to do a double – even a triple – take."

Examples include what appeared to be a worm being pulled out of the dirt by a bird, but which was, in fact, a diamond necklace; sticky toffee apples sitting alongside fairground ride tickets, adorned with sparkling ruby and diamond rings; eggs nestled in a towering pyramid of crystal champagne glasses; or a full moon shining down on nothing but a broken string of pearls.

From the 1960s, Moore started designing jewellery for Tiffany & Co., including a range of circus figurines in the 1990s, which were inspired by Tiffany & Co.'s early connections with American showman P. T. Barnum, who founded The Grand Traveling Museum, Menagerie, Caravan & Hippodrome, which went on to become the Barnum & Bailey Circus in 1871. According to Gene Moore, one of Barnum's

OPPOSITE Gene Moore was well-known for his uniq and imaginative window displays, often using everyd objects such as egg flowers, fruit and household objects

FROM BROADWAY TO FIFTH AVENUE 73

LEFT Less is more: a broken pearl necklace being reflected by the moon in 1956, which was recreated in the windows of Selfridges in Oxford Street, London, in October 2024.

OPPOSITE Inspired by circus showman P. T. Barnum, Gene Moore created a range of sterling silver circus performer figurines during the 1990s.

elephants trampled eight men and had to be killed, at which point Charles Lewis Tiffany purchased the hide and displayed it in the store's window with a sign listing all the products that would be made from the leather. When the products arrived in store, the police had to be called to keep order due to the high demand.

Tiffany's was also involved in the wedding of Barnum's leading performer Tom Thumb, who was a mere 86cm (34in), to fellow performer Lavinia Warren in February 1863. There were over 2,000 guests in attendance, including the Astors, Vanderbilts and Roosevelts, and Tiffany created a silver filigree and gemstone horse-and-chariot for the newly-weds, which was displayed in the store's window in the weeks leading up to the wedding.

74 FROM BROADWAY TO FIFTH AVENUE

RIGHT In collaboration with film director, producer and co-writer Baz Luhrmann, Tiffany unveiled *The Great Gatsby* window to celebrate the opening of the film in April 2013.

FROM BROADWAY TO FIFTH AVENUE 77

TIFFANY
BLUE

TIFFANY & CO.

THE BLUE BOX

"Tiffany has one thing in stock that you cannot buy of him for as much money as you may offer; he will only give it to you. And that is one of his boxes."
The New York Evening Sun, 1899

What must be the most coveted packaging in history, famously known as the only thing you can't buy at Tiffany & Co., the robin-egg blue boxes (with an undertone of green) have truly stood the test of time.

Created by Charles Lewis Tiffany in 1845 for the launch of Tiffany, Young & Ellis's first Catalogue of Useful and Fancy Articles, the right shade of blue was carefully chosen to reflect the trends of the time. In 1853, Empress Eugénie of France, the greatest fashion icon of the time, chose a robin's egg, pale turquoise blue as her official colour. Charles, fully aware of how influential the Empress was, lost no time in immediately claiming it as Tiffany's official colour.

OPPOSITE First created in 1853, trademarked over 100 years later and given its own custom Pantone name, the Tiffany Blue Box is synonymous with luxury, opulence and glamour.

The formula, known as Tiffany Blue, is a closely guarded secret and was trademarked in 1998, along with the Tiffany Blue Box. In 2001 it was given its own custom Pantone name, 1837 Blue, after the year that Tiffany & Co. was founded. The fact that it's exclusive to Tiffany and unavailable to the public makes it all the more covetable.

The only addition, which was added 100 years later, was the white satin ribbon tied around every box, evoking the idea that each and every one is a treasured object in itself and only adding to the anticipation of the delectable secrets held within. You know that if you're handed that blue box, you're getting something really special.

THE BLUE BOOK

The first issue of the Blue Book was in fact the Catalogue of Useful and Fancy Articles that Tiffany, Young & Ellis produced in 1845, to enable them to reach a wider market across the country. It was the first mail order catalogue of its time and included everything from pipes, riding whips, personalized scissors, portable ink stands, pin cushions, silver snuff boxes, paint boxes, purse clasps, slippers, quill toothpicks and silver thimbles. There was a small amount of jewellery at the back.

Today, the Blue Book is anything but a simple mail order catalogue but instead a dazzling and carefully curated opera of decadence and opulence. It is now purely about displaying the high-end jewellery and extraordinary gemstones that Tiffany's is so renowned for in the hope that the wealthiest people in the world will fall in love with them.

There are no prices – a minor detail for Tiffany's wealthiest customers – just image after image of exquisite jewels that for

OPPOSITE Inspired by the favourite colour of Empress Eugénie, the nineteenth-century fashion icon and wife of Napoleon III, Charles Lewis Tiffany immediately claimed the robin-egg blue for Tiffany & Co.

84 TIFFANY BLUE

most of us remain only the stuff of dreams. Never-before-seen pieces and unique bespoke designs are created specifically for the yearly spectacle and each Book is treated to a celebrity-laden launch party.

How do you get a copy of the Blue Book? The answer is that if you're deemed to have spent enough on jewels at Tiffany's – not including sterling silver – over the course of the year one will automatically land on your doormat. Do bear in mind we're talking many thousands of dollars here, though. Otherwise, it might be a matter of begging and pleading a kind-looking salesperson at your nearest Tiffany & Co. store.

TIFFANY AND ETIQUETTE

This may not be common knowledge, but there is in fact a Tiffany Blue Book that you can find for under $20 and order from your local bookshop. First published in 1961 and written by Tiffany's former chairman, Walter Hoving, *Tiffany's Table Manners for Teenagers* is the ultimate tongue-in-cheek etiquette book for teens. It was illustrated by Joe Eula, the renowned fashion illustrator who went on to be creative director for Halston, and this ingenious little blue book is quite a gem in its own right.

Including every eventuality from getting seated and the soup course right through to the dessert course, no stone is left unturned. You will learn how to talk to the young man or woman next to you without looking like a "startled beetle", how to hold your knife correctly and how to eat asparagus – with your fingers – and that it's perfectly acceptable to blow your nose at the table as long as you use a handkerchief, *not* your napkin.

OPPOSITE From the humble Catalogue of Useful and Fancy Articles containing snuff boxes and toothpicks to the sought-after glossy brochure of Tiffany's finest bespoke jewellery that it is today, the Blue Book has stood the test of time.

LOVE AND ENGAGEMENT

Tiffany & Co.

Fifth Avenue and 37th Street, New York

Tiffany Engagement Rings

Can only be purchased direct from Tiffany & Co.'s Establishments in New York, Paris and London

Diamonds and other precious stones selected especially for their purity, color and individual merits, set singly or in combination as desired

A few moderate priced rings with first quality stones, mounted in 18 karat gold or platinum are listed below

Solitaire diamond rings	**$30, 53, 85, 100** upward
With diamond studded shanks	**$55, 75, 95** "
Solitaire ruby, pearl, emerald or sapphire rings	$50 "
With diamonds embedded in shank	$80 "
Two-stone rings: two diamonds or diamond and other precious stone	$55 "
With diamonds in shank	$85 "
Three-stone rings: three diamonds or two diamonds with pearl, ruby, emerald or sapphire	$65 "
Half hoops of five diamonds or alternating with other precious stones	$75 "
Princess rings of diamonds, pearls or sapphires	$100 "
Banquet or dinner rings, various combinations	$150 ".

Cuts of the above or richer rings showing sizes of stones, styles of mountings and prices mailed upon request, also Tiffany 1907 Blue Book containing over 600 pages of descriptions and prices of other articles

Fifth Avenue New York

Tiffany & Co. always welcome a comparison of prices

THE TIFFANY SETTING

"Into every girl's life a diamond should fall."
Elizabeth Taylor

In 1886 the world's most recognizable and iconic engagement ring was born, the Tiffany® Setting. The meticulously engineered design was unusual for the times; elaborate, diamond-encrusted masterpieces were generally the rings du jour. But staying loyal to his ethos, Charles Lewis Tiffany didn't want to appeal to just the wealthiest of customers, he wanted an engagement ring that a couple with any budget could afford.

ABOVE For nearly 140 years, Tiffany has been the top destination for newly engaged couples to find the ring of their dreams.

OPPOSITE A 1907 advertisement for Tiffany & Co engagement rings from simple diamond solitaires from $30 to three-stone rings with diamonds, rubies and emeralds from $65.

LOVE AND ENGAGEMENT 89

His ring was a diamond solitaire, with a brilliant cut – triangular and kite-shaped facets spreading outwards from the centre of the stone, to enhance the light travelling through it. The solitaire was set in six prongs that lifted it above a slender gold band. Until then, diamonds had been set close to the band and this setting allowed the light to pass through the prongs and the diamond, heightening its shine and brilliance. Nothing was to distract from the diamond's eternal beauty, regardless of its clarity or carat. In 1903, Franklin Delano Roosevelt, the future president, proposed to his wife-to-be, 19-year-old Eleanor, with a Tiffany diamond engagement ring. Afterwards she wrote him a letter saying, "You could not have found a ring I would have liked better."

The design remains unchanged today and the Tiffany® Setting is still the jeweller's most popular engagement ring, more than 130 years later, and can be chosen with a yellow gold, platinum or rose gold band. Prices range from $1,500 to over $130,000.

OPPOSITE Charles Lewis Tiffany created the Tiffany® Setting in 1886. A simple yet exquisite solitaire is suspended in a six-prong setting that allows the light to shine through for extra shine and brilliance.

WILL YOU JOIN ME IN BELIEVING
THAT ABSOLUTELY EVERYTHING IS POSSIBLE?
BECAUSE AS LONG AS WE'RE TOGETHER, IT IS.

WILL YOU?

THE TIFFANY® SETTING.
130 YEARS OF EXTRAORDINARY.

TIFFANY & CO.
NEW YORK SINCE 1837

LEFT Marilyn Monroe helped put diamonds back on the map with her hit song 'Diamonds Are a Girl's Best Friend' from the film *Gentlemen Prefer Blondes* in 1953.

'DIAMONDS ARE A GIRL'S BEST FRIEND'

The story of diamonds has not always been plain sailing. After the Great Depression and two world wars, sales had plummeted. In fact, not only were Americans not buying, but they were selling off their diamonds in droves. The diamond industry was in trouble. In 1947, Harry Oppenheimer, chairman of one of the world's largest diamond suppliers, De Beers, came up with a clever idea. Diamonds needed a new lease of life, and with the help of advertising agency N.W. Ayer & Son, he pulled off the ultimate marketing campaign, with the slogan: "A diamond is forever".

Not only was the campaign aimed at men, who were buying 90 per cent of engagement rings at the time, but representatives were sent into senior school assemblies and classrooms with the aim of catching them young. Men were told that the bigger the diamond, the greater their love. Over 100 newspapers were targeted and film stars and celebrities of the time were seen dripping in sparkling gems. In 1953 a huge stroke of luck hit when the song 'Diamonds Are a Girl's Best Friend' featured in the film *Gentlemen Prefer Blondes,* starring Marilyn Monroe. The future of the diamond was sealed.

The campaign was a huge success and secured the association of diamonds with love and romance. The diamond engagement ring became the one piece of jewellery that everyone, regardless of wealth or status, had to have. Today, 87 per cent of all engagement rings sold contain diamonds. A clever marketing idea indeed.

IS A TIFFANY RING WORTH IT?

With so many jewellers to approach – from large brands to independent retailers and designers – is investing your hard-earned cash in a Tiffany & Co. engagement ring really worth the money?

According to a former Tiffany diamond grader, the answer is a resounding yes, if you can afford it, comparing the decision to buying a Mercedes or a Subaru. Both cars, but different. Every Tiffany diamond grader is a graduate of the Gemological Institute of America (GIA) and their job involves grading up to 150 stones a day, despite each diamond already having been graded by the original supplier or distributor and being accompanied with a GIA certificate confirming its quality. Each stone will have been graded for the 4Cs: colour (how clear the diamond is); cut (symmetry, depth and geometry); carat (weight, not size); and clarity (flawlessness) under stringent laboratory conditions. These are then passed on to be regraded yet again by an experienced reviewer who allocates a Tiffany certification which guarantees the highest grading standards. Each and every Tiffany engagement ring also comes with a lifetime guarantee as well as free resizing, cleaning and polishing throughout its life.

And then of course, as Holly Golightly would attest, Tiffany's customer service is impeccable, regardless of your budget. Bear in mind that no Tiffany store has its full range of engagement rings on display at any one time. Do your research, take in a wish list, and a week or so later you will be called in to view a much wider selection.

When you have chosen your ring – whether it be timeless, classic and simple or an over-the-top statement; whether gold or platinum; round, oval or pear-shaped – nothing quite beats the promise of that little blue box with its white satin ribbon.

OPPOSITE (ABOVE) Wedding and engagement ring set: Tiffany® Settin engagement ring with a brilliant-cut diamond, and platinum wedding band inset with diamonds.

OPPOSITE (BELOW) Soleste diamond ring with a beautifu cushion-shaped diamond in the centre, flanked by diamonds.

94 LOVE AND ENGAGEMENT

LOVE AND ENGAGEMENT 95

TIFFANY
IN FASHION

THE GODMOTHER OF FASHION

"Jewel pieces will be huge and affluent. The road is paved with huge and humorous jewels."
Edna Woolman Chase, *Vogue*

Often referred to as the unsung hero of fashion, publicist Eleanor Lambert put more fashion icons on the map than Anna Wintour could ever dream of. She had a client list that read like the Who's Who of the fashion industry including Mainbocher, Hattie Carnegie, Lilly Daché, Christian Dior, Yves Saint Laurent, Pierre Cardin, Oscar de la Renta, Geoffrey Beene, Bill Blass, Halston, Calvin Klein, Ralph Lauren, Donna Karan and Stephen Burrows, but she didn't stop there. She launched the CFDA (Council of Fashion Designers of America), the International Best Dressed List, the Coty Awards, the Costume Institute at the Metropolitan Museum of Art in New York and the Met Gala as well as New York and Paris fashion weeks.

OPPOSITE Model Marisa Berenson wearing Tiffany's lavish "golden trophy of precious pets brought back from a jewel-safari, to wear in herds or alone on one arm" according to *Vogue* on 1 March 1970.

Always preferring to promote her clients rather than herself, Eleanor stayed behind the scenes and changed the face of American fashion. It was she who recognized the importance of jewellery and fashion and how the two were inextricably linked. Eleanor started working with Tiffany & Co. during the 1930s and the company was her longest-standing client – she was over 100 years old when she finally closed her Tiffany files. According to John Tiffany, great-great-nephew of Charles Lewis Tiffany and former employee of Eleanor Lambert, the powers that be at Tiffany took a lot of persuading to appreciate the connection between fashion and jewellery, especially in taking advantage of fashion photography that was starting to appear from the likes of Edward Steichen, Horst and Cecil Beaton.

"It's almost impossible to believe, but she really had to convince them. Tiffany didn't think their jewellery had anything to do with fashion," explained John Tiffany. "She kept suggesting that they send jewellery to the magazine editors and embrace the fashion designers, but they thought it was absolutely absurd."

Louis Comfort Tiffany was partly to blame for this draconian way of thinking. When art nouveau made way for art deco in the late 1920s, he never embraced the new style and he felt the same way about the new medium of photography. The only time that Tiffany jewellery was allowed to be photographed was when it was put on display at world fairs and expositions. After his death in 1933, this was all to change.

OPPOSITE Eleanor Lambert, grande dame and publicist extraordinaire, put Tiffany on the fashion map and in every magazine fro*m* *Vogue* to *Vanity Fair*.

FROM *VOGUE* TO *HARPER'S BAZAAR*

There was certainly no lack of jewellery in fashion magazines such as *Vogue* and *Harper's Bazaar* during the first few decades of the twentieth century, from Cartier, Mauboussin and Van Cleef & Arpels to department stores including Lord & Taylor, Saks Fifth Avenue and Bendel. By the 1930s there was barely an issue that wasn't awash with the finest in luxury from opulent furs to extravagant hats and sparkling jewels. The Great Depression may have been raging across America, but fashion magazines were determined to keep everybody's spirits up.

Finally, Eleanor Lambert was able to convince Tiffany, advertising manager George Heydt in particular, to allow jewellery to be photographed for the editorial pages of magazines. Tiffany's first foray into the world of photographic fashion editorial was in *Vogue* (1 July 1933). Photographed by Edward Steichen, it featured Mrs Julien Chaqueneau, the Broadway actress, sitting at a mirrored dressing table wearing a delectable "ashes-of-roses" satin tea gown from Bergdorf Goodman and a selection of jewels from Tiffany & Co. The dressing table was also set with Tiffany silver, including a hairbrush and mirror vanity set, perfume bottles, vases and accessory boxes.

A year later, for the 1 December 1934 issue of *Vogue*, in a caption that read: "The ultimate in Christmas loveliness", an elegant brunette wore an emerald crepe dress with a snowy-white fox fur cape draped across her shoulders, accessorized by two exquisite pearl necklaces and sparkling emerald and diamond bracelets and a ring from Tiffany & Co., reportedly worth a total of $90,000. The jeweller had got the message.

However, the party was over almost before it had begun. War broke out again in 1939, and when the Nazis invaded Paris in June 1940, Tiffany & Co.'s focus – like during the American

OPPOSITE
Debutante Alice Gwynne Allen dressed for the Beaux Arts Ball, wearing a stack of diamond-encrusted Tiffany bracelets for *Vogue*, 15 January 1940.

Civil War and the First World War – was to manufacture products for the military, such as precision parts for anti-aircraft guns, rather than jewellery.

It wasn't until the 1950s that Tiffany once again courted the media. In 1955, Walter Hoving, former president of Fifth Avenue department store Lord & Taylor, and the owner of Bonwit Teller, bought control of Tiffany & Co. Publicity-savvy, and with over 20 years of experience in fashion retail, he hired Tiffany's first jewellery designer in decades, Jean Schlumberger, and wasted no time in getting Tiffany back into the press. In the 15 November 1956 issue of *Vogue*, a double-page spread featured Jean's new Wardrobe of Settings for the Tiffany Diamond as well as an introduction to his work for Tiffany. A new chapter was about to begin.

OPPOSITE Exquisite jewels for a night on the town. Ruby, sapphire and diamond bracelets and earrings, and sapphire moonstone hair clip featured in *Vogue*, November 1940.

BELOW Before the war, Tiffany & Co jewellery often featured in *Vogue*, including these diamond and aquamarine bracelet and ring in 1936.

104 TIFFANY IN FASHION

TIFFANY IN FASHION 105

106 TIFFANY IN FASHION

NEW BEGINNINGS

Walter Hoving knew exactly what he wanted and was unapologetic about it. He was considered firm but kind by his employees and the reputation of Tiffany & Co. was always at the forefront of his mind. He had high standards, which included no diamond rings for men, absolutely no silver plate, and no charge accounts for customers who were rude to staff. He closed several accounts for bad behaviour and told the *New York Times* that he saw no reason for "retailers to take guff from people."

No Sellotape was to be used in gift-wrapping and under no circumstances were the white ribbons on the Tiffany blue boxes to be knotted. When interviewing potential employees, he reportedly asked them to choose between well and badly designed objects and hired or rejected them according to their taste.

But Hoving knew how fashion magazines worked and he understood that fashion and jewellery could not live without each other. Not only did he have an eye for the best designers, hiring individuals who would become legendary – Jean Schlumberger, Elsa Peretti and Paloma Picasso – he trusted them implicitly, giving them free rein to do what they wanted, but he understood the role of the fashion editor too. In a feature spread in the 1 March 1968 issue of *Vogue*, Ira von Fürstenberg, actress and Fiat heiress, wore a selection of gold Tiffany chains adorned with a selection of Donald Claflin diamond and jewel-encrusted sea dragons around her golden midriff. This was considered rather risqué, even for the 1960s. According to John Loring, author of *Tiffany in Fashion*, Walter Hoving wrote to *Vogue's* editor of the time, Diana Vreeland, stating, "You certainly have discovered a new area of the feminine body where Tiffany jewellery may be worn… If it

OPPOSITE Model Va[...]ylor, on the [co]ver of *Vogue* November 1957), [w]earing Revlon's [Re]d Caviar lipstick [an]d nail enamel and [a] Schlumberger [fo]r Tiffany diamond [je]wellery.

TIFFANY IN FASHION 107

goes much lower, I'm afraid they'll fire me off the vestry of St. Bartholomew's Church."

Hoving's eye for publicity, and his own high standards, had a clear effect. When he joined Tiffany in 1955, the company was turning over $7 million, and when he stepped down as chairman in 1980, turnover was $100 million. Tiffany went from a company that appeared to have passed its heyday to become one of the most famous jeweller's in the world.

UNSUNG HEROES OF TIFFANY

Jean Schlumberger, Elsa Peretti and Paloma Picasso are names that are synonymous with Tiffany & Co., but there were two other designers who were just as influential during their time but who somehow slipped under the radar as the decades passed.

BELOW Antique Donald Claflin 18k gold, platinum and diamond earrings with green peridot gemstones weighin 17 carats.

108 TIFFANY IN FASHION

RIGHT A chic wrap-around, 18-carat gold serpent bracelet with oval and pear-shaped rubies and diamonds by Donald Claflin for Tiffany.

TIFFANY IN FASHION 109

Donald Claflin was hired in 1966 and became known for his quirky and witty designs often based on well-known children's stories and nursery rhymes, such as *Alice in Wonderland* and *Humpty Dumpty* as well as mythical creatures including sea dragons and bejewelled turtles. Birds, flowers and fruits were another favourite theme that continued throughout his tenure at Tiffany.

Often working in highly polished 18-carat yellow gold, he used elaborate combinations of gemstones and enamels – he was particularly keen on diamonds and coral – and in 1969 he created Tiffany's first collection centred around their newly discovered gem, tanzanite. In 1976 he left Tiffany and joined the Italian jeweller Bulgari.

After arriving in New York from art school in Germany, and showing her portfolio to Walter Hoving, Angela Cummings joined Tiffany as Donald Clafin's assistant. In 1974 her first signed collection was launched and it added her unique and exquisite work to the mix, inspired by nature as well as Japanese and Native American designs. Again, much of her jewellery was in 18-carat gold, but rather than gemstones, she loved to work with lapiz, jade, mother-of-pearl, coral, opal and wood. She put as much passion into working on an emerald necklace valued at $1 million as she did tracking down local cabinet makers for pieces of aged wood or sourcing cinnamon wood from Brazil, zebrawood from Kenya or rosewood from Europe.

According to the *New York Times*, in just one year, 1982, Angela's designs generated $10 million worth of turnover. She continued to work for Tiffany for a total of 18 years, but in 1984 she created her own independent line, Angela Cummings Fine Jewellery, and opened her first stand-alone boutique in Bergdorf Goodman, soon followed by Bloomingdale's, Neiman Marcus and Saks Fifth Avenue.

OPPOSITE Tiffany jewellery designer Donald Claflin is known for his housing bejewelled creations based on well-known nursery rhymes, including *Humpty Dumpty*.

OPPOSITE Created in 1981 by Angela Cummings for Tiffany, this unique necklace consists of a graduated series of 12 textured gold autumnal leaves in green gold, rose gold and yellow gold with two oversized leaf earrings.

ABOVE RIGHT Beautiful 18k gold flower bracelet by Angela Cummings inlaid with rhodochrosite, aventurine quartz, blue agate and frosted rock crystal.

RIGHT Angela Cummings often drew inspiration from nature. This Lotus Root hinged bracelet features carved jadeite depicting cross sections of the lotus plant.

TIFFANY IN FASHION 113

JEAN
SCHLUMBERGER

BACK TO NATURE

"I try to make everything look as if it were growing, uneven, at random, organic, in motion. I want to capture the irregularity of the universe."

Jean Schlumberger

Hailed as one of the twentieth century's greatest jewellery designers, Jean Schlumberger was the first named designer for Tiffany & Co. After a stint in Berlin to pursue a career in banking, at his parents' insistence, the Frenchman moved to Paris, where he worked for couturier Lucien Lelong. It was in Paris that he experimented with handmade jewellery using coral, shells and antique finds from flea markets.

In 1937, as luck would have it, one of his well-connected clients, Marina, Duchess of Kent was spotted by couturier, Elsa Schiaparelli, wearing a pair of earrings that Jean had made. She snapped him up and he made the fanciful buttons that she became famous for, along with costume jewellery.

After moving to New York after the Second World War, he briefly opened his own jewellery salon, and in 1956 was discovered by Tiffany & Co.'s Walter Hoving, who recognized his extraordinary talent immediately. He was given his own exclusive workshop and salon on the mezzanine floor of the Fifth Avenue store, with its own private elevator. It was not long

OPPOSITE Jewellery designer Jean Schlumberger at his drawing board at home in Bisdary on Guadeloupe.

– the year 1958, in fact – before he became the first jewellery designer to win the coveted Fashion Critics' Coty Award.

Following on from Paulding Farnham and Louis Comfort Tiffany, Jean created a huge array of stunning pieces of jewellery based on nature – shells, fish, birds, starfish, flowers, fruit, sea urchins, grasshoppers, parrots and butterflies – in gold, gemstones and enamel. Being self-taught with no official training in jewellery design meant that he had no constraints; he simply designed what he loved. Stellene Volandes, the current editor of *Town & Country*, says, "His jewels are like nature unleashed."

ABOVE One of Jean Schlumberger's most famous pieces for Tiffany, Bird on a Rock, was originally created in 1965, reintroduced in 199 and is still available at Tiffany today.

118 JEAN SCHLUMBEREGER

SOCIALITES AND STARLETS

Jean Schlumberger's creativity and love of nature, along with the fantastical wit and charm of his work, put Tiffany & Co. back on the fashion map as one of the world's leaders in jewellery design, a reputation that was to last well past Jean's 40-year tenure and into the present day.

He became a great friend of Diana Vreeland, the legendary editor of *Harper's Bazaar* and *Vogue*. She adored his creativity and he made exclusive pieces for her, including the Trophée de Vaillance, a brooch featuring a shield with spears and encrusted with diamonds, emeralds and amethyst. He was also a favourite of New York's wealthy society ladies including Bunny Mellon, Babe Paley, Gloria Vanderbilt, Wallis Simpson and Daisy Fellowes, as well as Hollywood's finest such as Greta Garbo and Lauren Bacall.

BELOW Jean Schlumberger sapphire- and diamond-encrusted flower earrings set in platinum and 18k gold. The ruby and diamond version appeared on the cover of *Vogue* in December 1959.

JEAN SCHLUMBERGER 119

OPPOSITE AND ABOVE Jackie Kennedy was a loyal fan of Jean Schlumberger's enamel and diamond "Croisillon" and "Dots" bangles, often referred to as the "Jackie bracelets".

JEAN SCHLUMBERGER 121

However, Jean's most famous celebrity clients were probably Jackie Kennedy and Elizabeth Taylor. Jackie wore his "Croisillon" and "Dots" bangles – coloured enamel bands stitched in gold or encrusted with diamonds – so often that they became known as "Jackie bracelets". Today, they can reach anything from $30,000 to $80,000 at auction.

Perhaps one of Jean's most famous pieces was the fantastical Dolphin Brooch, a gift from Richard Burton, worn by Elizabeth Taylor to the premiere of the film *The Night of the Iguana* in August 1964, in which he starred with Ava Gardner. With polished gold scales encrusted with diamonds, sapphire eyes and emerald lips, mounted on platinum and 18-carat gold, Richard nicknamed the brooch "The Iguana" in honour of the film. In 2011, it sold at Christie's, as part of "The Collection of Elizabeth Taylor: The Legendary Jewels" for a staggering $1,202,500. It was a particular favourite of Elizabeth, who said in her book, *Elizabeth Taylor: My Love Affair with Jewels*, "Richard and I had a sentimental attachment to the Schlumberger iguana brooch because it symbolized when we were so madly, happily in love."

OPPOSITE The fantastical Dolphin Brooch that Richard Burton gifted to Elizabeth Taylor in 1964 to celebrate the opening of his film, *The Night of the Iguana*. The brooch became known as "The Iguana".

JEAN SCHLUMBERGER

ELSA PERETTI

FROM HALSTON TO TIFFANY

"I want my designs to be clear, simple but sublime."
Elsa Peretti

Dressed in a long red Halston cashmere dress – it didn't matter that it was for evening – and with a Spanish harvest basket stuffed with business papers, make-up, cigarettes and money, as well as a black shawl slung over her shoulders, Elsa Peretti was ready for the business meeting that would change her life forever.

Inspired by a vase she found in a bric-a-brac shop, she had created one of her first pieces of jewellery – a small, sterling silver bud vase which she wore around her neck with a leather thong. The designer Giorgio di Sant'Angelo featured the necklace in his show in 1969 with a rose stem nestled inside and it caused a sensation. In the early 1970s Elsa went on to create more bud vases but on a chain, as well as sterling silver bone bracelets and earrings for her friend, the designer Halston.

OPPOSITE Elsa Peretti, former model and Tiffany jewellery designer, was the epitome of style. Seen here wearing her famous Diamonds by the Yard at the 21 Club in New York, December 1975.

ABOVE Elsa Peretti loved to use natural materials in her jewellery such as these beautiful lacquered Japanese wooden bangles in red, brown and black.

OPPOSITE Elsa Peretti wearing Diamonds by the Yard and her famous Vase Necklace, reminiscent of the first design she created when modelling for fashion designer, Halston.

ELSA PERETTI 129

The pieces sold out immediately and Halston recognised that to be the success she was to become, Elsa needed the right facilities. In 1974, he introduced her to Harry Platt, Tiffany's chairman, and Walter Hoving, and, dressed in her red Halston gown, she was hired in just 15 minutes. The rest, as they say, is history.

Two thousand guests attended the official launch of the Elsa Peretti Department on 24 September 1974 and her first collection sold out on the same day. According to the *New York Post*: "A crowd of women milled around the square glass cases that held Elsa Peretti's new collection of jewellery and clamoured to buy", and over the next few months thousands of customers a day piled into the store, standing five-deep at the Elsa Peretti counter.

ABOVE Elsa Peretti died in March 2021 at the age of 80, but her soft, sculptural designs continue to be bestsellers at Tiffany & Co. today.

BONES AND SKELETONS

Having not stocked silver jewellery for a quarter of a decade, Elsa brought sterling silver back to Tiffany and turned it, once again, into a luxury, must-have item. Her designs were sculptural, sleek and sensuous. One of her most recognizable pieces, originally created in the early 1970s, was the beautifully sculpted bone cuff, which is still one of Tiffany's bestsellers today. In 1978 she even designed a pair of sterling silver candlesticks that were intended to replicate the shape of a human femur. An X-ray of her own femur was the inspiration.

There was nothing macabre about her love for bones, even if they are an unusual choice for such a popular piece of jewellery. In the catalogue Fifteen of My Fifty With Tiffany, produced for an exhibition in 1990, she explained, "As a child, I kept

BELOW Elsa Peretti introduced sterling silver to Tiffany with her bone cuffs, launched over 50 years ago, and they are one of her most iconic and recognizable pieces to this day.

on visiting the cemetery of a seventeenth-century Capuchin church with my nanny. All the rooms were decorated with human bones. My mother had to send me back, time and again, with a stolen bone in my little purse. Things that are forbidden remain with you forever."

Sophia Loren, Angelina Jolie, Naomi Watts and Kate Winslet are all fans, with Liza Minnelli being the greatest of all. "Elsa brought out all these things – the bone bracelet I remember the best. Everything was so sensual, so sexy. I just loved it. It was different from anything I'd ever seen, and I'd seen a lot. I've only really worn Peretti jewellery from then on."

Elsa loved to travel and was inspired by the natural forms and tactile objects she found, from bones and lima beans to snake skeletons, scorpions and starfish. She was fascinated by the mechanics of a scorpion and created a necklace with fully articulated tails and claws, and the inspiration for her famous snake necklace came from the end piece of a rattlesnake tail that she was given as a good luck charm.

On a trip to Jaipur, India, in 1974, she came across an ancient way of knitting gold into fabric and on her return translated it into an incredibly light and sparkly gold knit mesh, which became earrings, necklaces and even a bra designed by Halston. The bra was relaunched in 2019 and worn by Zoë Kravitz at the *Vanity Fair* Oscars after-party.

Her horse buckle belt, which was influenced by horse riders in Mexico and featured regularly as part of Halston's catwalk shows, is still available at Tiffany today.

OPPOSITE
Fascinated by the scorpion's mechanics, Elsa Peretti created her sterling silver Scorpion necklace with fully articulate claws that encircle the wearer's neck while its body and tail hang as a pendant.

ABOVE The delicate chains and bezel-set diamonds of Diamonds by the Yard heralded a change at Tiffany in 1977, turning diamonds into something that could be worn every day.

RIGHT Elsa Peretti's most famous design, the open heart, shown here suspended from her finely knitted gold mesh, a technique she came across in Jaipur, India, in 1974.

A LASTING LEGACY

Keen to attract a younger market, Walter Hoving asked Elsa Peretti to create something affordable that women could buy for themselves and Diamonds by the Yard were born. She set 12 small diamonds in gold casings at uneven distances on a delicate chain and they were an instant success with everyone from college girls to heiresses. Soon different lengths and varying numbers of diamonds were added to the collection, along with bracelets, rings and earrings. In 1977, *Newsweek* wrote that Tiffany & Co. had sold two miles of Diamonds by the Yard, adding that Elsa had started the "biggest revolution in jewellery since the Renaissance."

Elsa once explained, "My client is myself. A working woman. It was the '60s, early '70s and there was a new generation of working women who wanted to buy jewellery for themselves – jewellery to wear day and night. Jewellery to represent their freedom." She remained with Tiffany until her death, nearly 50 years after she joined, and her legacy continues today.

Her most famous design, the open heart, was inspired by a piece of sculpture by Henry Moore in which she noticed an asymmetrical, fluid shape of a heart, created by a void in the sculpture. It is still a bestseller. In the early 1980s she expanded her collections to include homeware, from tableware to decorative pieces in sterling silver, glass and crystal. Like her jewellery, these were known for their fluid shape and tactile quality and are still timeless and iconic pieces today.

PALOMA PICASSO

DARLING OF PARIS

"My purpose in life is to make everything more beautiful."
Paloma Picasso

The ultimate society party girl, Paloma Picasso hung out with Yves Saint Laurent and Karl Lagerfeld at Le Palace in Paris and Andy Warhol, Bianca Jagger and Debbie Harry at New York's Studio 54. The daughter of artists Pablo Picasso and Françoise Gilot, Paloma always knew that her famous heritage meant she was going to need to make a name for herself in her own right. A lover of vintage clothes that she picked up in Parisian flea markets – unusual for the early 1970s – and a maker of costume jewellery, she caught the eye of Yves Saint Laurent at the tender age of 19 and not only became his muse, friend and confidante, but designed costume jewellery for his House too.

OPPOSITE Still designing jewellery for Tiffany today, Paloma Picasso launched her bold and colourful jewels in December 1980.

She was the only one of his muses to inspire an entire collection, an accolade that even better-known muses, Betty Catroux and Catherine Deneuve, could not claim. Paloma's daily outfits of 1940s-style padded shoulders, over-the-knee dresses, platform shoes and turbans inspired the controversial 1971 Scandal collection. Controversial because Paris was not yet ready to be reminded of the war years, but at the same time it was one of the most beautiful collections he ever created.

Following a year at jewellery design school and a stint working for the renowned Greek jeweller Zolotas, Paloma was noticed by John Loring, design director at Tiffany, and was asked to present a table setting for an exhibition in 1979. The following year she was offered a contract by Walter Hoving and became one of Tiffany & Co.'s exclusive jewellery designers, alongside Elsa Peretti.

ABOVE Paloma brought Tiffany's jewellery into the 1980s with strong shapes and colours such as these large Graffiti X 18k gold earrings with tourmaline, citrine and diamonds.

RIGHT Paloma Picasso's love of colour and bold gemstones are displayed perfectly in this 18k gold cross necklace with round-shaped pink and green tourmaline, aquamarine and citrine gemstones.

PALOMA PICASSO 141

STREET FASHION AND GEMSTONES

Paloma Picasso and Elsa Peretti could not have been more different in their styles and approach to jewellery design, which created the perfect balance for Tiffany & Co. The 1980s saw fashion designers such as Christian Lacroix and Claude Montana come to the fore, and with them came brash, bold colour and strong shapes, and Paloma fitted the mould perfectly. She loved working with large colourful gemstones and semi-precious stones such as rubellite, tanzanite, aquamarine, tourmaline, moonstone and citrine.

Her first collection, named Paloma's Graffiti, was based on the graffiti she saw on New York's streets and on the subway. She wanted to turn what was seen as a negative into something positive, something beautiful. "At the time everybody was talking against graffiti," she said. "I thought,

ABOVE Amethyst and 18k gold Graffiti X earrings inspired by the graffiti that Paloma Picasso saw on New York's streets and subway.

ABOVE Paloma Picasso's 18k gold Loving Heart earrings (the range also includes pendants and bracelets in sterling silver, rose and yellow gold) are still available today.

let's give a good name to graffiti." The collection is still available at Tiffany today.

As well as creating modern and colourful statement jewels, which *Vogue* described as "'real' jewelry in a modern sense", Paloma also became the face of her jewellery in Tiffany's advertising campaigns. It was a bold move: Yves Saint Laurent had done it for his men's fragrance in the 1970s, but this was a first for Tiffany & Co. Who could forget Paloma's striking black hair, red lipstick, red suits and bold jewellery, the epitome of the 1980s and a symbol of the decade's modern, powerful and sophisticated woman? Nearly half a decade later and Paloma is still designing for Tiffany, sharing her legacy with both Jean Schlumberger and Elsa Peretti.

A CULT ICON

THE STARS OF TIFFANY

"I'm just crazy about Tiffany's!"
Holly Golightly, *Breakfast at Tiffany's*

When Judy Garland married Vincente Minnelli in 1945, MGM told her to choose *anything* she wanted from Tiffany & Co. as a wedding present. Marjorie Hart, part-time salesgirl and author of *Summer at Tiffany*, was working in the store that day. "Over a murmur of voices, I heard someone laugh – a familiar laugh. Was I dreaming? My heart raced when I look up as the room turned quiet. Judy Garland was entering the Fifth Avenue revolving door with an elegant-looking man. Of course – Vincente Minnelli! They were laughing, as if they were sharing the world's best joke."

At first, Garland chose a simple gold brooch but she was encouraged to try emeralds. She opted for an emerald bracelet with square diamonds and a matching brooch that could be broken into two clips.

OPPOSITE Bassist and singer Esperanza Spalding wearing Jean Schlumberger for Tiffany woven gold and diamond Chevron Fringe necklace.

A CULT ICON 147

Tiffany's Walter Hoving knew the value of celebrity and since the 1960s Tiffany & Co. has been associated with the glamorous women of Hollywood and beyond. Audrey Hepburn famously wore Jean Schlumberger's setting of the Tiffany Diamond in the 1961 publicity photographs for *Breakfast at Tiffany's*. Elizabeth Taylor was photographed wearing her Jean Schlumberger Iguana Brooch on several occasions, and of course, there was Jackie Kennedy and her favourite diamond and enamel "Jackie" bracelets. Liza Minnelli is believed to own every single piece of Elsa Peretti jewellery that she ever designed, in every single metal, and she still wears the pieces today.

From Hollywood stars to music royalty, Tiffany & Co. were the official jewellers behind Beyoncé's 2023 Renaissance Tour, which showcased hundreds of custom-made pieces, including diamond necklaces and earrings, Elsa Peretti sterling silver bone cuffs, a metallized silver peephole cowboy hat adorned with Tiffany blue gemstones made in collaboration with milliner Stephen Jones and an Elsa Peretti mesh dress which combined both Diamonds by the Yard and Elsa's mesh ribbons. The star of the show was Queen Bey's spectacular 4.5-carat white diamond earpiece, which she wore throughout the tour.

And it's not just pop greats who are the faces of Tiffany, including Lady Gaga, Ariana Grande and Dua Lipa (who wore a $10 million Tiffany necklace to the Met Gala in 2023). So too are faces from the sporting stage. Britain's Emma Raducanu stunned spectators when she wore $37,100 worth of Tiffany jewels for her opening match at Wimbledon in 2022.

OPPOSITE Beyoncé performing in Amsterdam during her Renaissance World Tour in 2023, wearing custom-made, diamond-encrusted glasses and silver peephole cowboy hat.

OPPOSITE Actress Anya Taylor-Joy at the 78th Venice International Film Festival in September 2021, wearing a Jean Schlumberger for Tiffany diamond leaves necklace.

OVERLEAF Magazine advertisement featuring today's lock by Tiffany, crafted in 18k gold with hand-set diamonds which hang from a delicate oval link chain.

THE RED CARPET

There is nothing as important as the red carpet in terms of celebrity product placement. The right piece on the right celebrity is priceless, from Jennifer Lopez at the Met Gala wearing the Tiffany Céleste Wings necklace in platinum and 18-carat gold with a 20-carat oval diamond to Emily Blunt at the SAG Awards in a glittering Jean Schlumberger petal fringe necklace in platinum and 18-carat gold with 152 round brilliant diamonds. Wherever they are taken, the photographs are seen worldwide in every news outlet and on every social media platform.

Tiffany & Co. now has a reach of over 25 million across its social media platforms – the largest being Instagram – and nearly 70 brand ambassadors, including Beyoncé and Jay-Z, Kendall Jenner, Anya Taylor-Joy, Pharrell Williams, Tracee Ellis Ross, Rosie Huntington-Whiteley and Hailey Bieber. It's a level of success beyond anything Walter Hoving could have imagined. Collaborating with the world of fashion and celebrity certainly paid off.

TIFFANY & CO.

TIFFANY TODAY

In January 2021, Tiffany & Co. was bought for a staggering $15.8 billion by French conglomerate LVMH. It already has an established stable of fashion brands including Christian Dior, Givenchy, Louis Vuitton, Celine, Fendi, Emilio Pucci, Marc Jacobs and Kenzo, and this was considered to be one of the largest acquisitions within the luxury industry.

Since the takeover, there have been advertising campaigns by Grace Coddington, fashion aficionado and former *Vogue* creative director; engagement rings for men; and super-sleek modern jewellery collections such as Tiffany Lock, Tiffany T, Tiffany HardWear and Tiffany Knot. In a bid to target Gen Z, Tiffany has also joined forces with celebrities such as *The Queen's Gambit* actress Anya Taylor-Joy and Korea's K-pop star Rosé, and worked on collaborations with Supreme, Fendi, Pokémon and Pharrell Williams. However, the collaboration

ABOVE Grace Coddington, former creative director of *Vogue*, styled this sleek advertising campaign for the launch of the gold and diamond Tiffany T collection in 2014.

154 A CULT ICON

ABOVE Inspired by a 1975 bracelet from the archives, the Tiffany T bracelet pays homage to Tiffany & Co.'s famous T motif.

with Nike produced $400 shoes that did not impress hardcore "sneakerheads" despite the sterling silver shoe box that could be made on request.

It has been a rough ride for Tiffany over the last few years. Two months after the $500 million relaunch of the The Landmark on Fifth Avenue, a huge fire broke out in the basement and ground floor, requiring 80 firefighters to dampen the blaze.

But Tiffany & Co. is an institution that will not be beaten. It may be struggling to find its way once again in a fiercely competitive and changing market, but there is little doubt that the legacy of Charles Lewis Tiffany will live on in its all-shining, glittering way.

A CULT ICON 155

INDEX

(page numbers in *italic* refer to captions)

Academy Awards (Oscars) 40, *41*
Allen, Alice Gwynne *102*
American Civil War (1861–65) 10, 24, 102–4
Angelbaby *45*
Angoulême, Duchess of 30
Anne, Queen 54, *56*
The Architectural Guidebook to New York (Morrone) 65
Art Deco 8, 56, *62*, 65, 66, *66*, 100
Art Nouveau 8, 52, 56, 100
Atlas clock 69
aventurine quartz *113*

bangles *121*, 122, *129*
Barnum, P. T. 72, *74*
Basquiat, Jean-Michel 71
Beaton, Cecil 100
Beaux-Arts 65
Beaux Arts Ball *102*
Bejewelled by Tiffany (Loring) 28
Bendel 102
Berenson, Marisa *99*
Bergdorf Goodman 72, 102, 111
Beyoncé *38*, 41, 148, *148*, 151
Bird on a Rock *12*, *37*, 38–40, 41, *119*
Birds in Flight Necklace *12*
blue and green enamel flower brooch *45*
Blue Book 18, 62, 81, 83–5, *84*
Blue Box 7, 8, *8*, 81–5, *81*, *82*, *84*, 94, 107
Blue Room, White House 52
bonbonnière spoon *23*
bones 127, 131–4
Bonwit Teller 72, 104
bracelets 66, *102*, *104*, *109*, 127
brand ambassadors 151
Breakfast at Tiffany's 7, 37, 38, *40*, 61, *61*, *62*, 148
Bridgham family 26
broken pearl necklace *74*
brooches 8, *13*, 18, *19*, 24, *24*, *32*, 45–6, *45*, *46*, 49, *49*, 54, 119, 122, *122*, 147–8
Brunswick Diamond 37
Burton, Richard 122, *123*

Cannes Film Festival *7*
Cartier 102
Catalogue of Useful and Fancy Articles 18, *19*, 62, 81, 83–5, *84*
Céleste Wings necklace 151
Charles X 30
Chase, Edna Woolman 99
Chevron Fringe necklace *147*
Christie's 122
circus figurines 72, *74*
Claflin, Donald 46, 107–11, *108*, *109*, *110*
Coddington, Grace 154, *154*

"The Collection of Elizabeth Taylor: The Legendary Jewels" 122
Cook, Charles T. 49
Coty Awards 99, 118
Crazy About Tiffany's 7
"Croisillon" and "Dots" bangles *121*, 122
Cross & Cross 69
crystal 63, 72, *113*, 135
Cummings, Angela 46–7, 111, *113*

Daffodil Lamp 54
diamond and pearl brooch *2*
diamond grading 94
"A Diamond in the City" ("Une Diamant dans la Ville") exhibition (1995) 38
Diamond Jubilee (2013) 8, 66
Diamond Kings *12*, 31
"Diamond Skylight" 71
'Diamonds Are a Girl's Best Friend' *92*, 93
Diamonds by the Yard *127*, *129*, *134*, 135, 148
Dolphin Brooch *49*, 122, *123*
dragonfly brooch *46*
Driscoll, Clara 54, *54*

earrings 8, 21–4, *22*, *41*, *104*, *108*, *113*, 117, *119*, 127, 132, 135, *142*, *143*, 148, 154

156 INDEX

Elizabeth II 8, 66
Elizabeth Taylor: My Love Affair with Jewels (Taylor) 122
Ellis, Jabez Lewis 18
emerald, diamond and platinum ring *66*
engagement rings 88–95, *89*, *94*, 154
Eugénie, Empress 30, *31*, *32*, 82

Farnham, Paulding *24*, *26*, 45, 49–51, *49*, *50*, 63, 118
fashion photography 100, 102
avrile glass 52, *52*
feuilles de groseillier brooch *32*
Fifteen of My Fifty With Tiffany 131–2
First World War (1914–18) 56, 65, 104
Formula 1 11, *11*
4 Cs 94
French Crown Jewels 13, 30–1, *31*, *32*
French Revolution 19, 63
Fürstenberg, Ira von 107

Gaga, Lady *38*, 40, *41*, 148
Garbo, Greta 119
Gardner, Ava 122
Garland, Judy 147
garnet *49*, 54–6, *56*
Gemological Institute of America (GIA) 94
gemstones 56, *104*, *141*, 142–3, *142*, 148
Gentlemen Prefer Blondes *92*, 93
Gilded Age 8, *20*, 26–9, *26*, 30

Givenchy 154
gold serpent bracelet *109*
"golden trophy of precious pets" 99
Golightly, Holly 7, 37, 38, 61, *61*, *62*, 63, 94
Graffiti X earrings *142*
Grand Traveling Museum, Menagerie, Caravan & Hippodrome 72
grapevine necklace *56*
Great Depression (1929–39) 8, 65, 66–7, 93, 102
Great Seal of the United States 10, *10*

hair clips *104*
Hall Championship Cup 11, *11*
Halston 85, 99, 127, *129*, 132
HardWear 154
Harper's & Queen 7
Harper's Bazaar 102, 119
Hart, Marjorie 69–70, 147
Hepburn, Audrey 7, 38, *40*, *62*, 63, 148
Heydt, George 102
Hirst, Damien 71
Hollywood 119, 148, 154
Horst, Horst P. 100
Hoving, Walter 72, 85, 104, 107–8, 111, 117, 130, 135, 148
Humpty Dumpty 111

"The Iguana" brooch 122, *123*, 148
International Best Dressed List 99
Isabella II 30–1

Jackie bracelets *121*, 122, 148
jade 111, *113*
Japanese wooden bangles *129*
Jay-Z 41, 151
Jazz Age 56, 65
Jazz necklace *62*
"The Jewelry Box" 71

Kennedy, Jacqueline ("Jackie") 8, *121*, 122, 148
Kennedy, John F. ("JFK") 8
King of Diamonds 13, 30–1
Kinney, Col Peter 10
Klein, Calvin 99
Knot jewellery 154

Lambert, Eleanor 99–102, *100*
The Landmark, Fifth Avenue 41, *45*, 61, *61*, *64*, 65, *67*, *68*, 69–71, *71*, *89*, 117, 155
lapel watch *26*
lapis lazuli 111
Le Palace, Paris 139
Leaves necklace *151*
Lincoln, Mary Todd 24
Lincoln, Abraham 8, 24, 30
Lock jewellery *151*, 154
Lord & Taylor 69, 102, 104
Loring, John 28, 107, 140
Lost Genius 51
Lotus Root bracelet *113*
Louis-Philippe I 18
Louis XVIII 30
Louisiana Purchase Exposition (1904) 54, *56*
Lubin hair oils 18
Luhrmann, Baz *76*
LVMH 154

INDEX 157

McClure, George 18
McKim, Mead & White 65
Madison Avenue, New York 28, *28*
Mainbocher 99
Marina, Duchess of Kent 117
Martin, Cornelia Bradley 30
Mauboussin 102
Met Gala 99, 148
Metropolitan Museum, New York 21
Metropolitan Museum of Art (MMA), New York 99
Metzler, Henry Frederick 69
Minnelli, Liza 148
Minnelli, Vincente 147
Modern Art 65
Monroe, Marilyn *92*, 93
Montana, Claude 142
Moore, Gene 72–4, *72, 74*
Moore, Henry 135
Moore, John C. 20–1
Morgan, Junius Spencer 30
mother-of-pearl 111
Musée des Arts Décoratifs, Paris *37*, 38

Napoleon III *32, 82*
National Geographic 20
nature-inspired *47, 49*, 107, 118
necklaces 7, *7*, 8, 13, *13*, 23–4, 38–41, *38, 40, 41*, 45, 46–7, 54, *56*, 62, 66, 72, *74*, 102, 111, *113*, 127, *129*, 132, *132, 141, 147*, 148, 151, *151*
New York Crystal Palace Exposition 19, 23
New York Evening Post 62
New York Evening Sun 81
New York Fashion Week 99

New York Post 130
New York Times (*NYT*) 107, 111
New York Yankees 11
New Yorker 67
Newsweek 135
The Night of the Iguana 122, *123*
Nike 155
N.W. Ayer & Son 93

Obama, Barack and Michelle 8, 66
one-dollar bill *10*
opal 46, 54–6, *57*, 111
open heart design 7, *134*, 135
Orchid Blossom brooches 49–51, *49, 50*
Orient pearls 23
Oviedo, Don Esteban Santa Cruz de 23

Palace of Jewels 13, 31
Palais Royal 18
Palazzo Grimani, Venice *64*, 65
Paley, Babe 119
Paloma's Graffiti 142, *142*
Pantone name *81*, 83
Paris Exposition Universelle (1889) 49, *49*
Paris Fashion Week 99
Paris Herald 50
pendants 8, *19*, 24, 38, 63, 66, *132, 143*
Peppard, George 38, *62*
Peretti, Elsa 7, 13, 47, 63, *71*, 107, 108, 124–35, *127, 129, 130, 131, 134*, 140, 143, 148
peridot 108

Picasso, Pablo 139
Picasso, Paloma 107, 108, 136–43, *139, 141, 142, 143*
platinum gold 38, *49*, 62, 66, 66, 90, 94, *94, 108, 119*, 122, 151
Platt, Harry 130
Pulitzer, Joseph 30

Queen Anne's lace 54, *56*

Raducanu, Emma 148
Reed, Gideon French Thayer 19
Renaissance 135
Renta, Oscar de la 99
rhodochrosite *113*
Ribbon Rosette necklace 38
Ribbons necklace *40*
rings *19*, 20, 45, 72, 88–95, *89, 94*, 107
robin's egg blue 8, 52, 81
Roosevelt, Franklin Delano ("FDR") and Eleanor 90
Roosevelt, Theodore 8
Rosé 154
rose gold 90, *113*
Russell, Lillian 24

Safford, Katherine May 30
SAG Awards 151
Sant'Angelo, Giorgio di 127
Saint Laurent, Yves ("YSL") 99, 139, 143
Saint Louis Exposition (1904) 54, *56*
Saks Fifth Avenue 102, 111
sapphire- and diamond-encrusted flower earrings *119*
sapphires *45, 46, 47, 49*,

54–6, 66, *104*, 122
Scandal collection (1971) 140
Schiaparelli, Elsa 117
Schlumberger, Jean 8, *12*, *37*, 38, *40*, 41, *45*, 46, *47*, *49*, 56, *70*, 104, 107, *107*, 108, 114–23, *117*, *119*, *121*, 143, 148, *151*
scorpion necklace *132*
sea life-inspired jewellery *47*, *49*, 107, 118
Second World War (1939–45) 69, 102, 117
Selfridges *74*
Sex and the City 8
silverware 20, *20*, 26
Simpson, Wallis 119
Smithsonian Institute 72
soleste diamond ring *94*
solitaire diamonds *88*, 90, *90*
Sotheby's 54
Spalding, Esperanza *147*
Staff and Field Officer's sword *10*
stained-glass windows 52, *52*
State Rooms, White House 52
statue of Liberty 10
Steichen, Edward 100, 102
sterling silver 7–8, 11, 20–2, *23*, *26*, 63, *74*, 85, 127, 131, *131*, *132*, 135, *143*, 148, 155
studio 54, New York 139
Summer at Tiffany (Hart) 69–70, *147*
Supreme 154
Swiss diamonds *24*

T Collection 154, *154*, 155
Taylor, Elizabeth 89, 122, *123*, 148
Taylor-Joy, Anya 7, 151, *151*, 154
Taylor, Va *107*
tazza dish *20*
tea set *26*
Temple of Fancy 62
Tiffany Ball (1957) 38
Tiffany Blue 7, 8, *8*, 71, 78–85, *82*, *84*, 107, 148
Tiffany, Charles Lewis 8, 13, 17–19, *17*, 26, 62–3, *90*, 100
Tiffany Diamond 34–41, *37–41*, *37*, *38*, *40*, 90, 94, *94*, 104, *107*, 148, *150*
Tiffany Girls 54
Tiffany in Fashion (Loring) 107
Tiffany, John 100
Tiffany lamps 54, *54*
Tiffany, Louis Comfort 45, 46, 51, 52–6, 63, 100, 118
Tiffany Sea Life Necklace *45*
"Tiffany Style" glass *52*
Tiffany, Young & Ellis 18, 62, 81, 83
Tiffany® Setting 89, *90*, *94*
Tiffany's Table Manners for Teenagers (Hoving) 85
Town & Country 118
Trophée de Vaillance 119
Twain, Mark 28
21 Club, New York *127*

"Une Diamant dans la Ville" ("A Diamond In the City") exhibition (1995) 38
US Inaugural Ball (1861) 24
US Open 11, *11*

Van Cleef & Arpels 102

Vanderbilt, Gloria 119
Vanity Fair 40, *41*, *100*, 132
Vanity Fair Oscar Party (2019) 40, *41*, 132
Vase Necklace *129*
Venice International Film Festival *151*
Victoria, Queen 31
Vogue 37, 38, 99, *99*, 100, 102, *102*, 104, *104*, 107, *119*, 143, 154, *154*
Vreeland, Diana 107, 119

Wall Street Crash (1929) 66
Wallis, Duchess of Windsor 119
Wardrobe of Settings 38
Wardrobe of Settings for the Tiffany Diamond 104
Warhol, Andy 139
Warren, Lavinia 74
Watts, Naomi 132
wedding rings *94*
white gold brooch *13*
White House 52
White, Stanford *28*
Whitehouse, Mary Sheldon 38
Williams, Pharrell 151, 154
Wimbledon 148
Winslet, Kate 132
Wintour, Anna 99
Wisteria Lamp 54

yellow gold 38, *45*, *49*, 90, 108, *109*, 111, *113*, *119*, 122, *141*, *142*, *143*, 151, *151*
Young, John Burnett 8, 17, 62–3

Zolotas 140

INDEX 159

CREDITS

The publishers would like to thank the following sources for their kind permission to reproduce the pictures in this book.

Key: l – left, r – right , b – bottom, t – top and c - centre

Advertising Archive: 80, 91, 154

Alamy: adsR 20; /Album 56, 57; /Allstar Picture Library 92; /Associated Press 36; /Bailey-Cooper Photography 68; / Chronicle 31; /Collection Cristophel 60; / EMU History 55; /FineArt 53; /Marshall Ikongraphy 39; /Patti McConville 13, 67, 71, 152; /Penta Springs Limited 26; /Photo 12 82; /Retro AdArchives 47; /Roman Numeral Photographs 27

Bridgeman Images: 19; /Christie's Images 32; /Photo © NPL - DeA Picture Library 52

Getty Images: Alain Benainous/Gamma-Rapho via Getty Images 123; /Bettmann 40, 101; /Steve Campbell/Houston Chronicle via Getty Images 24; /Stephane Cardinale - Corbis/Corbis via Getty Images 150; /Steven Ferdman 11; /Ron Galella/Ron Galella Collection via Getty Images 120;/PL Gould/Images 128; /Yvonne Hemsey 138; /Taylor Hill 44; /Horst P. Horst/Conde Nast via Getty Images 103, 104, 105, 116; /Hulton Archive 16; /Nick Hunt/Patrick McMullan via Getty Images 130, 131; /Lynn Karlin/WWD/Penske Media via Getty Images 126; /Mark Kauzlarich/Bloomberg via Getty Images 70; /Frederic Lewis 28-29; /Kevin Mazur/WireImage for Parkwood 149; /Cindy Ord/WireImage 76-77; /Paramount Pictures 62;/Jay Paull 88; /George Pimente 41; l/The Print Collector 33; /John Rawlings Condé Nast via Getty Images 106; /Rocco Spaziani/Archivio Spaziani/Mondadori Portfolio via Getty Images 6; /Bert Stern/Conde Nast via Getty Images 98

Heritage Auctions/HA.com: 10 l, 12, 21, 22, 23, 25, 45, 46, 48, 63, 66, 75, 89, 95 t. 95b, 108, 109, 110, 113 t, 113 b, 118, 119, 121, 129, 133, 134 t, 134 b, 140, 141, 142, 143, 155

Private Collection: 9, 84

Scala: Image copyright The Metropolitan Museum of Art/Art Resource/Scala, Florence: 49, 50-51

Shutterstock: Glasshouse Images 64; / Gregory Pace 146; /Tamer A Soliman 10 r

Smithsonian Institution: National Museum of American History 73, 74

Treasure Fine Jewellery: 112

Author Acknowledgements
Thank you to my editors Isabel Wilkinson and Emma Hanson for giving me the opportunity to write about one of my all-time favourite stores, and my agent Isabel Atherton at Creative Authors for knowing me so well.